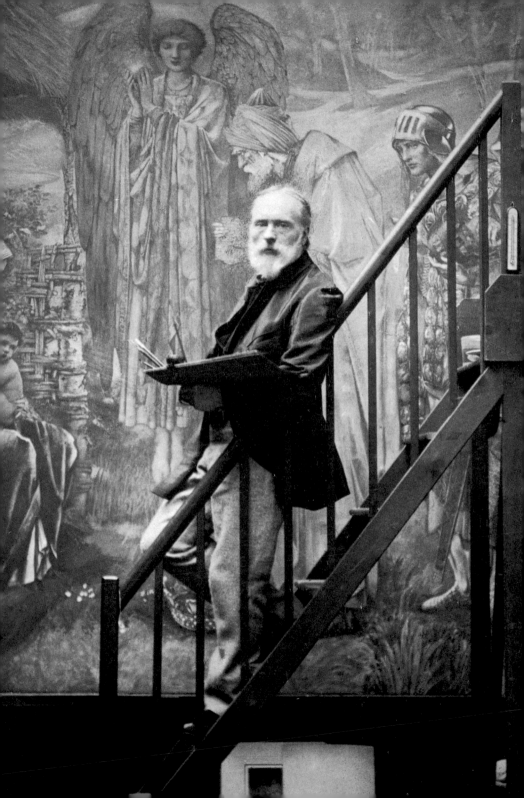

National Portrait Gallery
Insights
The Pre-Raphaelite Circle
Jan Marsh

The Pre-Raphaelite Circle

Published in Great Britain by National Portrait Gallery Publications,
National Portrait Gallery, St Martin's Place, London WC2H 0HE

For a complete catalogue of current publications please write to the
address above, or visit our website at www.npg.org.uk/publications

ISBN 1 85514 352 6

A catalogue record for this book is available from the British Library.

Publishing Manager: Celia Joicey
Editor: Susie Foster
Design: Pentagram
Production Manager: Ruth Müller-Wirth
Printed and bound in Hong Kong

The publisher would like to thank the copyright holders for granting
permission to reproduce works illustrated in this book. Every effort
has been made to contact the holders of copyright material, and any
omissions will be corrected in future editions if the publisher is
notified in writing.

Contents

Edward Burne-Jones
Barbara Leighton, printed by Frederick Hollyer, 1890

Edward Burne-Jones is seen here in his studio at the Grange, North End Lane, Fulham, standing in front of his painting *Star of Bethlehem* (now at Birmingham Museums & Art Gallery).

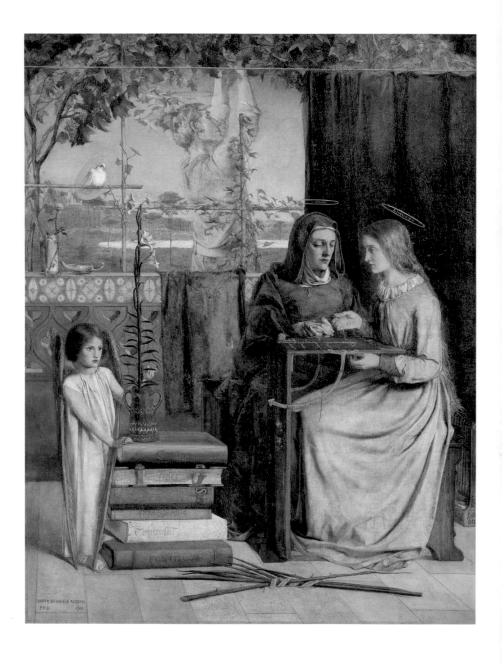

Introduction

In 1853 Dante Gabriel Rossetti told his Pre-Raphaelite Brother Thomas Woolner that his new picture contained all the important themes: Art, Friendship, Love. These were in fact the same links that bound the Pre-Raphaelite circle together. Art – pictorial and poetic – was of central concern to all their lives, closely laced to ties of friendship, including and often inspired by love: romance, sexual attraction, marriage.

The story begins with the Pre-Raphaelite Brotherhood, formed in London at the end of 1848. 'We were really like brothers, continually together and confiding to one another all experience bearing on questions of art and literature,' wrote William Rossetti. 'We dropped using the term "Esquire" on letters, and substituted "P.R.B." There were monthly meetings, at the houses and studios of the various members ... occasionally a moonlight walk or a night on the Thames.'

The PRB was led by three high-spirited young artists: John Everett Millais, William Holman Hunt and Dante Gabriel Rossetti. Recruiting painters Frederic Stephens and James Collinson, sculptor Thomas Woolner and Rossetti's brother, William, they chose the name 'Pre-Raphaelite' in protest against the moribund academic principles that had dominated western art since the Renaissance. The idea of a 'brotherhood' came from the contemporary German artists known as the Nazarenes or *Lukasbrüder* after the patron saint of painters, St Luke.

The Pre-Raphaelite aim was to paint directly 'from nature' – places, people and objects seen in clear light – while also conveying a spiritual or moral message. History, religion and literature were their sources, and as models they used themselves and their friends, rather than ideal types. They mocked the teaching of the Royal Academy, founded in 1768 by

The Girlhood of Mary Virgin
Dante Gabriel Rossetti, 1848–9

For this painting of the Virgin Mary sewing under her mother's instruction, the artist used his sister Christina as the model for Mary, and their own mother Frances Rossetti as the model for St Anne.

William Holman Hunt
John Ballantyne, 1865

The artist is shown in his studio, wearing an Arab robe and cap from his travels in the Middle East. He is at work on a depiction of *The Finding of the Saviour in the Temple* (1854–60), which was begun in Jerusalem and completed in London.

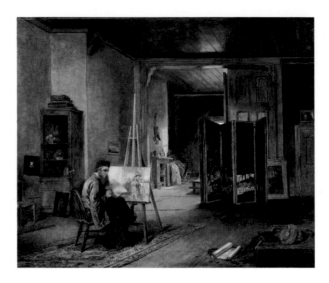

Sir Joshua Reynolds, as out of date and 'sloshy'. Millais quipped that Reynolds should be renamed 'Sir Sloshua'. The other hate figure was Rubens, a robust, physical painter. 'Spit here,' the PRB commanded whenever his name appeared in a book.

Instead, they commended early European artists like Memling, Van Eyck, Giotto and Gozzoli. According to Holman Hunt, reproductions of Italian frescoes prompted the Brotherhood's formation. 'Millais, Rossetti and myself were all seeking some sure ground, some starting point for our new art,' he wrote. 'As we searched through this book of engravings, we found in them ... that freedom from corruption, pride and disease for which we sought. Think what a revelation it was to find such a work at such a moment.'

There was also a national element to their challenge, to counter the high regard paid to French art. Praising artists like Hogarth, Blake and Palmer, and the genius of the Romantic poets, the PRB were self-conscious Young British Artists of their day.

Introduction

Rossetti wrote a sonnet for 'The Young Painters of England, in memory of those before Raphael', urging them to ambition:

> Which of ye knoweth he is not that last
> Who may be first by faith and will?

As William Bell Scott remarked, they were 'of great but impatient ability'. Shortly before the actual formation of the Brotherhood, Rossetti and Hunt drew up a list of 'Immortals', which, they declared, 'constitutes the whole of our creed'. Those in whom they believed included Christ, Dante, Chaucer, Shakespeare, Goethe, Tennyson and both Brownings, as well as a selection of early Renaissance painters and 'Early Gothic Architects'.

But the boys of the Brotherhood were not always so earnest. In a parody of Keatsian melancholy, Rossetti proposed a 'mutual suicide association', for members who felt weary of life. But 'it is all of course to be done very quietly, without weeping or gnashing of teeth. I, for instance, am to go in and say, "I say, Hunt, just stop painting that head a minute, and cut my throat"; to which he will respond by telling the model to keep the position as he shall be only a moment ...'

As well as meeting more or less regularly, the PRB kept a collective journal and launched a magazine called *The Germ*, containing Pre-Raphaelite poems and criticism. It was 'a small publication put forth by a set of crazy poetical young men, who call themselves the "Pre-Raphaelian brethren" and seek in all things for the "simplicity of nature"', wrote poet Bessie Parkes, one of its few readers. 'In one of the first numbers is a lovely poem called "The Blessed Damozel" (what a title) worthy of the very best company ...'

This poem, by Rossetti, reflected PRB liking for archaic imagery:

The Pre-Raphaelite Circle

The Rossetti Family
Lewis Carroll, 7 October 1863

This photograph was taken in the garden of Tudor House, Chelsea, by Lewis Carroll (Charles Lutwidge Dodgson), the author of *Alice in Wonderland*, who was a keen and skilful photographer. It was a 'memorable day', he recorded. The members of the Rossetti family pictured include (from left to right) Dante Gabriel, Christina, Frances Lavinia and William Michael.

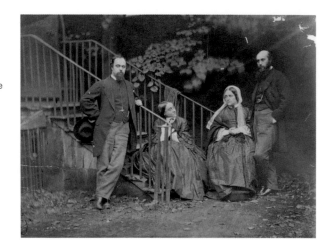

> The blessed Damozel leaned out
> From the gold bar of heaven:
> Her blue grave eyes were deeper much
> Than a deep water, even.
> She had three lilies in her hand,
> And the stars in her hair were seven.

The first Pre-Raphaelite venture to include other friends and associates – among them Christina Rossetti, Walter Deverell and Ford Madox Brown – *The Germ* set a future pattern of widening but coherent collaboration. Poet William Allingham and painter Arthur Hughes were early recruits to the circle.

The first PRB paintings, exhibited in spring 1849, attracted little attention. In 1850 the press disclosed the 'secret initials' and attacked the PRB for ugliness and irreverence. Charles Dickens was particularly savage towards Millais' *Christ in the Carpenter's Shop*. But it was good publicity. 'The P.R.B. has unquestionably been one of the topics of the season,' noted William Rossetti.

Though neither painter nor poet, John Ruskin was a key figure for the Pre-Raphaelites, writing with

religious fervour on the importance of art, the value of medieval buildings and the corruption of modern life. When he vigorously defended PRB sincerity, opinion began to swing; soon the Brotherhood was hailed as an artistic avant-garde.

Thus the movement came into being, only a little before the Brothers themselves began to move apart. Collinson left to become a priest, Woolner followed the gold rush to Australia and Holman Hunt set his sights on Egypt and Palestine. Herself exiled in Somerset, Christina Rossetti wrote a verse tribute:

> The two Rossettis (brothers they)
> And Holman Hunt and John Millais
> With Stephens chivalrous and bland
> And Woolner in a distant land,
> In these six men I awestruck see
> Embodied the great P.R.B.

In April 1853 the remaining Brothers gathered in London to sketch each other's portraits to send to Woolner. The results – several of which are illustrated here – testify to a distinguishing feature of the Pre-Raphaelite circle, that of mutual portraiture, in painting, drawing and caricature. A function of close friendship, this characteristic allows posterity to glimpse individuals and their relationships through their informal images of each other.

Pre-Raphaelite portraiture, especially in the early phase, is marked by the honest delineation of features and a certain ingenuousness of feeling that conveys the artist's understanding of the sitter's character. Because their era also coincided with the emergence of photography as a universal and 'true to life' form of portraiture, we can also compare portraits taken by the lens with those created by pencil or brush, and debate the extent to which personality is conveyed in different media – a question nicely complicated by the

Edward Burne-Jones and William Morris
Frederick Hollyer, 1874

This photograph was taken in the garden of the Grange, North End Lane, Fulham. Close friends from their student days, Burne-Jones and Morris joined the Pre-Raphaelite circle in 1856.

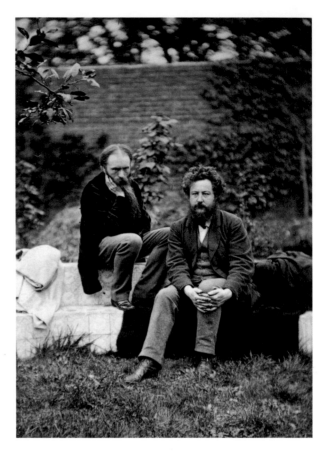

development of art photography, aspiring to the condition of painting.

By the mid 1850s the depleted Brotherhood had gathered new adherents. 'The Pre-Raphaelite movement has done some good and will do more,' declared fellow artist Joanna Boyce; 'aided by Ruskin's words, they have taught us that an artist's strength lies in a child-like sincerity and in the shunning of pride.' Others who moved into the orbit included PRB model Elizabeth Siddal, Joanna's brother George Boyce,

Introduction

painters John and Rosa Brett, the young Simeon Solomon, poet Algernon Swinburne and, most importantly, William Morris and Edward Burne-Jones. By this time, Frederic Stephens had relinquished painting in favour of art journalism and joined William Michael Rossetti as Pre-Raphaelite critic, bringing works to public attention.

In 1857 Madox Brown organised a Pre-Raphaelite exhibition in all but name (it had no official title and is known only by its venue in Russell Place, Fitzroy Street) that included work by most of the circle, and was succeeded by a touring selection that visited Boston, New York and Philadelphia. Later the same year, Rossetti recruited members of the circle to a madcap holiday scheme to decorate the vaulted ceiling of the new debating chamber at Oxford University with scenes from Arthurian legend. The painters were Rossetti himself, Burne-Jones, Morris, Spencer Stanhope, Arthur Hughes and young Val Prinsep. The following year a Pre-Raphaelite exhibiting space was created with the Hogarth Club, whose founder members included Madox Brown, Woolner, Hughes, Stephens, William Michael Rossetti, Burne-Jones and Morris, and soon grew to embrace the men of the whole circle.

Alfred Tennyson,1st Baron Tennyson
Thomas Woolner, 1856

Poet Laureate from 1850 to his death, Tennyson was the pre-eminent poet for painters and photographers.

The club may perhaps become something, wrote Allingham. 'It seems not small enough to be friendly, nor large enough to be important. There's an exhibition room to which nobody comes, and a Friday-night meeting to which nobody cares to come. Funerals are performed in the shop through which you pass, and there's a man in the passage who has seen better days and whom you may send out for beer.' Although, like the Brotherhood, the Hogarth Club soon folded, it represents a key moment in the history of the movement, bringing artists and associates together.

The Pre-Raphaelite world may be seen as comprising an inner group of close, sometimes quarrelsome friends, sharing social and artistic values, into and out of which others moved, a loose circle with a larger fringe. The most important of the other figures were painter George Frederic Watts, who both influenced and was influenced by the Pre-Raphaelites while never becoming one, and Poet Laureate Alfred Tennyson, who knew many of the group personally and whose lyrics and epics inspired so many Pre-Raphaelite pictures.

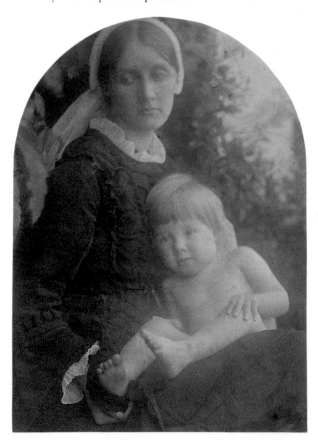

Julia Jackson (Mrs Herbert Duckworth, later Mrs Leslie Stephen) with her son Gerald Duckworth
Julia Margaret Cameron, August 1872

Photographer Julia Margaret Cameron consciously adopted the Pre-Raphaelite aesthetic. Holman Hunt was attracted to her niece Julia, who later married Leslie Stephen, becoming mother to Vanessa (later Bell) and Virginia (later Woolf).

Jenny and May Morris with Philip and Margaret Burne-Jones at the Grange, North End Lane, Fulham
Frederick Hollyer, 1874

May Morris recalled that the simple, unfashionable clothes worn by her sister and herself caused a young cousin to abuse them as 'medieval brutes'. Rejecting crinoline hoops and corsets, the women of the Pre-Raphaelite circle created their own dress style, based on historical examples from the Middle Ages and the Renaissance. Their daughters wore plain woollen garments, simply belted, with colourful beads and stout boots.

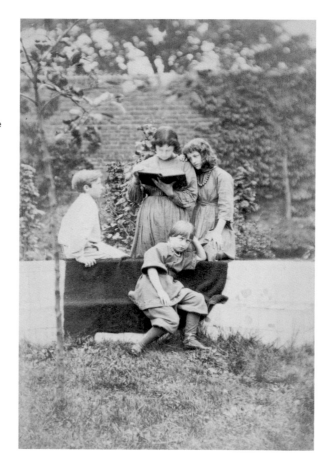

Like the PRB, the Hogarth Club had no women members, only guests. But they were not excluded from *The Germ* or the Russell Place exhibition and in general women were welcomed into the movement, as fellow artists, as well as models, sisters and wives. Generally, though not always, the men encouraged the women's aspirations, though Victorian gender attitudes still prevailed. When Georgiana Burne-Jones expressed her engraving ambitions, Ruskin replied that he could not imagine 'anything prettier or more wifely

The Burne-Jones and Morris families at the Grange, North End Lane, Fulham
Frederick Hollyer, 1874

This photograph shows (from left to right) Edward Burne-Jones's widowed father, Margaret Burne-Jones, Edward Burne-Jones, Philip Burne-Jones, Georgiana Burne-Jones, May Morris, William Morris, Jane Morris and Jenny Morris.

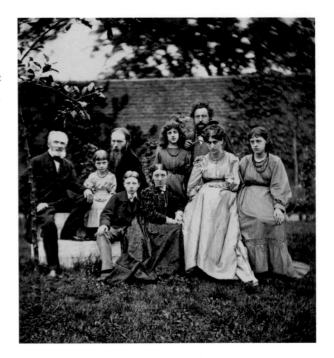

than cutting one's husband's designs on the wood block – there is just the proper quality of echo in it'.

Art historians sometimes insist that the term Pre-Raphaelite should be used only for early works before 1860 depicting dramatic or religious subjects in bright, clear colours and precise outlines. Later works, with softer lines, muted colours and dreamier subjects, are stylistically very different, more akin to what became known as the Aesthetic and Symbolist modes. That 'Pre-Raphaelitism' now happily includes both early and late styles is largely due to the personal lines of connection that extended over half a century. These linked the original PRB to a 'second wave', manifested particularly in the work of Burne-Jones, Solomon, photographer Julia Margaret Cameron and painters Frederick Sandys, Lucy and Catherine Madox Brown, Marie Spartali and Spencer Stanhope,

Introduction

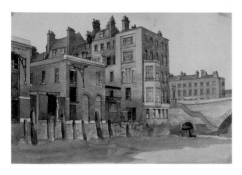 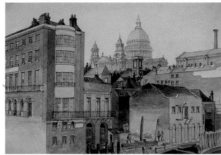

Views of the north bank of the Thames by Blackfriars Bridge
Unknown artist, 1840s

The studio occupied by Dante Gabriel Rossetti and, later, George Boyce was above the bay windows in the block above left, directly overlooking the river. St Paul's Cathedral is on the skyline (above right).

and thence to a later evolution encompassing the fine crafts, as practised by William de Morgan and May Morris.

The seed of the fine crafts revival was sown in 1861 with the formation of the design firm later known as Morris & Co. Initially an artists' partnership, this company produced art work of all kinds, including painted furniture, ceramics, stained glass and embroidered textiles. Morris led a convivial group of partners – weekly meetings were seldom very businesslike – including Burne-Jones, Rossetti, Madox Brown and architect Philip Webb, all supported and assisted by women such as Georgiana Burne-Jones, Jane Morris, Kate and Lucy Faulkner. 'Everyone in the small circle, man or woman, was called upon to join in,' explained May Morris.

Socially, the wider circle soon included ceramicist William de Morgan, whose marriage to painter Evelyn Pickering further consolidated the group. They met in studios and homes that have gained an almost legendary quality: studios such as those overlooking Blackfriars Bridge occupied by Rossetti, Boyce and Spencer Stanhope, or that in Red Lion Square, where Morris and Burne-Jones followed Rossetti and Deverell, close to where Morris & Co. would have its first workshop; and homes such as Little Holland House, where artists were always welcome, Tudor

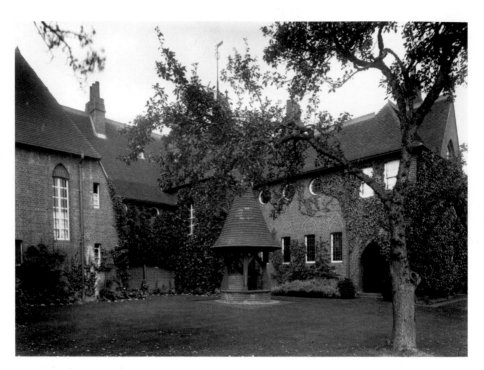

View from the garden of Red House
Sir Emery Walker, c.1899

Built from 1859 to 1860, Red House near Bexley in Kent was the Morrises' first home, where friends gathered at weekends. It was designed by Philip Webb for William Morris. The interior was decorated by William and Jane Morris, Burne-Jones, Elizabeth Siddal and others. It is now owned by the National Trust and open to the public.

House on Cheyne Walk, which Swinburne initially (and inebriately) shared with the Rossetti brothers, Madox Brown's hospitable home in Fitzroy Square, the Burne Joneses' house in Fulham and especially the places associated with the Morrises – Red House in Kent, Queen Square in Bloomsbury, Kelmscott House in Hammersmith and Kelmscott Manor in Oxfordshire.

One memorable party took place in May 1868, to celebrate publication of Morris's book *The Earthly Paradise*. Among the guests recorded by Allingham in his diary were Morris, Janey Morris and her sister, Ned ('thin') and Georgie ('in gorgeous yellow gown') Burne-Jones, Boyce ('has been ill'), Madox Brown ('oldened') and his wife, Lucy Brown, Philip Webb and Morris (in velvet jacket instead of evening dress):

Introduction

William Morris's study at Kelmscott House, Hammersmith
Sir Emery Walker, *c.*1895

At the end of his life Morris possessed a fine collection of late medieval illuminated manuscripts, an original source of inspiration for the Pre-Raphaelites.

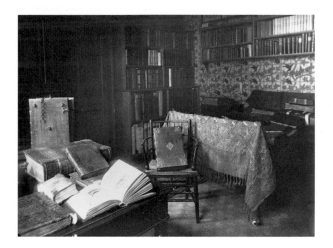

'A storm of talking. I away with D.G.R. about 1; walk first, then cab to Cheyne Walk, in and stay chatting and lounging till 3 in old fashion. "Come tomorrow and we'll go up together to my mother's."'

But while the circle was bound together by the belief that art and affection were of greater importance than wealth or social position, love tended to have a disruptive effect. Millais was an early loss to the inner group when he fell in love with Effie Ruskin, locked into an unhappy marriage, and in the late 1850s the relationship between Rossetti and Holman Hunt was strained by the former's flirtation with Annie Miller, Holman Hunt's model and protégée. By 1868 other friendships were tested to breaking point by Burne-Jones's affair with Maria Zambaco, and the mutual passion between Rossetti and Janey Morris.

Other interests bound friends closer together. Older and younger members of the Pre-Raphaelite circle joined Morris in the emergent movement to preserve Britain's architectural heritage, led by the Society for the Protection of Ancient Buildings (under threat not only from demolition and neglect but also from aggressive restoration). Broadly Liberal in their

politics, the Pre-Raphaelites shared Ruskin's critique of philistine materialism, though many grew conservative with age. William Morris was the single exception, moving decisively leftwards into the socialist movement, taking several friends and both daughters with him. Through this connection, he met the printer Emery Walker, collaborator in the Kelmscott Press.

From 1877 the Grosvenor Gallery became the new Pre-Raphaelite showcase, most especially for Burne-Jones. Other exhibitors (by invitation only) included Millais, Holman Hunt, Madox Brown, Hughes, Marie Spartali, Spencer Stanhope, Evelyn de Morgan and Helen Allingham. When the Grosvenor Gallery closed in 1890, the New Gallery took over its sphere of artistic interest; here earlier works by the Pre-Raphaelite circle were reintroduced to public view.

Over half a century, the Pre-Raphaelites were major players in the British art world, artistically and socially, with innovative ideas, enterprises and images that continue to be enjoyed and studied. Sometimes, the turbulent and tragic events of their shared lives seem to overshadow their art. In many ways, the personal and pictorial are indeed inseparable – the inevitable effect of combining Art, Friendship and Love.

During the twentieth century, Impressionist and modern art superseded Pre-Raphaelite work in popularity. But interest in both the art and the social history of the circle rose again around 1970, especially as the private lives of the participants were revealed through letters and biographies. Once denoting only the PRB, and exclusively male, the term Pre-Raphaelite also expanded, following the lines of friendship, influence and family descent, to encompass all those linked to the circle.

Introduction

Study for _Proserpine_
Dante Gabriel Rossetti, 1871

Proserpine is the Latin name for Persephone, symbol of spring in classical legend as the imprisoned wife of Pluto, lord of the underworld, during the winter. Rossetti used Jane Morris as the model for Proserpine while living at Kelmscott Manor.

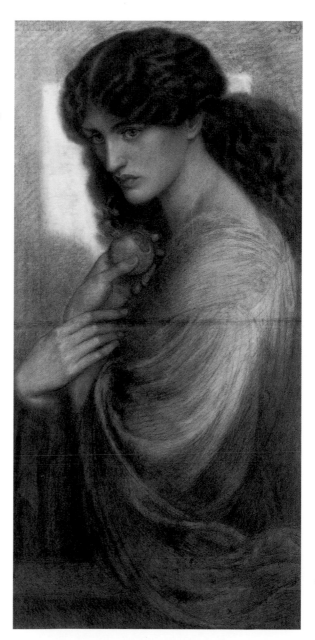

Biographies

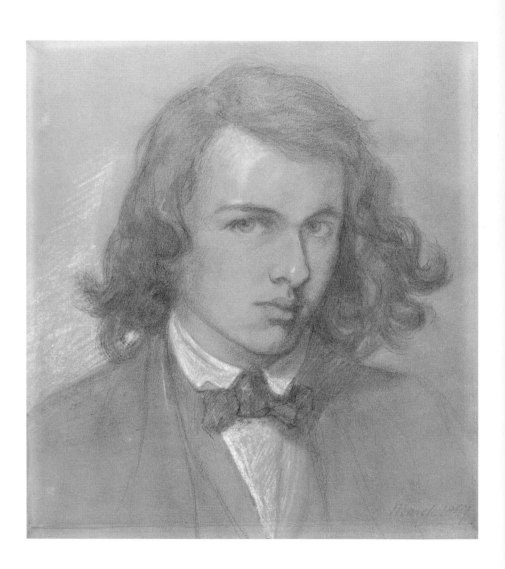

Dante Gabriel Rossetti (1828–82)

Rossetti was 'the planet round which we all revolved', according to Val Prinsep, and indeed he was the chief figure through the various phases of the Pre-Raphaelite movement – from the founding of the Brotherhood to the revival of the style in the 1890s, inspired by his pictures and poems. His early self-portrait shows the 'profusion of wild elf-locks' that he affected as a student and might well be entitled 'Portrait of the Artist as Romantic Poet' – an apt prophecy of his dual renown in art and literature.

Born in London, the son of an exiled Italian poet and elder brother to William and Christina, he left school at fourteen to study art. But, as he confessed, 'whatever I ought to do is just what I cannot do', and his first success came with the poem 'The Blessed Damozel', dramatising young lovers' yearning while obliquely alluding to the Italian struggle for liberation. In 1848 he met Ford Madox Brown, who was to be a lifelong friend, and then joined forces with William Holman Hunt, becoming a few months later the moving spirit behind the PRB. He was also a key contributor to *The Germ* with the tale of a Florentine artist who paints a vision of his soul as a young woman – a story that would inspire Simeon Solomon.

Temperamentally he was 'impetuous and vehement and necessarily also impatient; easily angered, easily appeased,' wrote his brother; 'keenly alive to the laughable as well as the grave or solemn side of things; superstitious in grain and anti-scientific to the marrow'. What did it matter if the earth went round the sun? he asked Holman Hunt.

Holman Hunt recalled, 'with his spirit alike subtle and fiery [he] was essentially a proselytiser, sometimes to an absurd degree ... but possessed, alike in poetry and painting, with an appreciation of beauty of the most intense quality'. Close to William Allingham and

Dante Gabriel Rossetti
Self-portrait, 1847

The image captures Rossetti's youthful personality as an ambitious dreamer, with 'an abundance of ideas, pictorial and literary', as his brother wrote, and a fixed antipathy to the modern world.

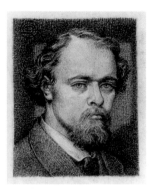

Dante Gabriel Rossetti
Self-portrait, 1870

As depression replaced dynamism, Rossetti's breakdown is foreshadowed in this drawing. 'It was in the early days only that the soul within had been truly seen in the face,' observed Holman Hunt sadly.

Thomas Woolner, and friendly with Tennyson and the Brownings, Rossetti often neglected art in favour of poetry. Moody and sensitive to criticism, he preferred, after early success, to sell pictures privately. His first major patron was John Ruskin, who reciprocally drew on Rossetti's knowledge of medieval art and literature for *Modern Painters IV* (1856). Rossetti participated in the Russell Place show and conceived the scheme to decorate the debating chamber at Oxford University, where, thanks to their shared passion for the past, he became close friends with William Morris, Edward Burne-Jones and Algernon Swinburne. A member of the Hogarth Club, he was also a partner in Morris & Co., designing stained glass and painted furniture.

To Burne-Jones he was the artist who 'taught me to have no fear or shame of my own ideas ... to seek no publicity, to be altogether myself'. Amid otherworldliness, however, Rossetti's ambition led him to relinquish medievalism for more popular paintings of alluring women. 'The early watercolours are the best,' noted Burne-Jones; later Rossetti 'got to love nothing else in the world but a woman's face'.

His early inspiration came equally from Dante's love for Beatrice and his own for Elizabeth Siddal, whom he married in 1860. On her untimely death in 1862, he placed in her coffin the manuscript poems he planned to publish following his translations of *Early Italian Poets* (1861). He moved to Tudor House in Chelsea, which he briefly shared with Swinburne. There his relationship with model Fanny Cornforth blossomed before fading when he fell in love with Jane Morris (known as Janey). Her image dominated his poetic and pictorial output thereafter, becoming the embodiment of the soulful 'Pre-Raphaelite woman'.

His *Poems* (1870) included those exhumed from Lizzie's grave and new ones inspired by Jane, with whom he had spent the summer at Kelmscott Manor. Then gossip, his sense of honour and a sustained

Dante Gabriel Rossetti

Dante Gabriel Rossetti
Lewis Carroll, 1863

'I'm quite sure there's not a woman in the whole world he couldn't have won for himself,' said Burne-Jones. 'Nothing pleased him more, though, than to take his friend's mistress away from him.' This photograph was taken at Cheyne Walk at the same time as Carroll's group photo of the Rossetti family (see page 10).

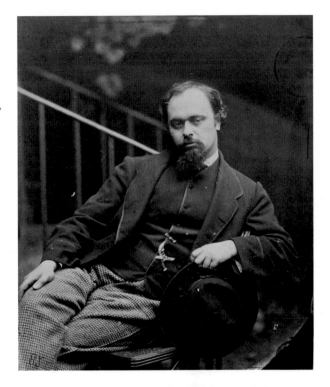

critical attack on the sensuality of his verse led to a breakdown, with delusions of persecution. Short and slight in youth, he became rotund and bald in middle age; at the same time he changed from a warm friend to an implacable enemy of Swinburne, Browning and others, whom he claimed had slandered him.

During a reclusive last decade, Rossetti continued painting and writing, dependent on the sedative drug chloral. His second volume, *Poems and Ballads*, appeared shortly before his death. Famed, not to say notorious, by this date, his paintings were first seen by the public in 1883, contributing to the revival of Pre-Raphaelite themes among younger artists and influencing the work of Walter Pater, Oscar Wilde, Aubrey Beardsley and Ezra Pound.

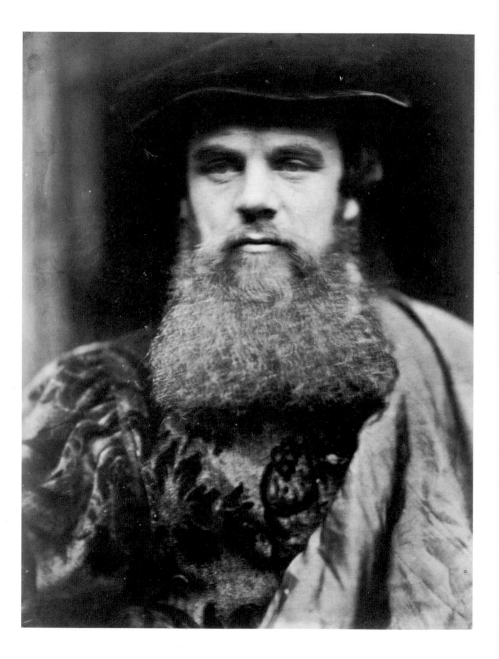

William Holman Hunt (1827–1910)

Recalling the initial Pre-Raphaelite principles as 'nothing less than irreverent, heretical and revolutionary', Holman Hunt challenged conventional picture-making. Why should compositions be always pyramidal, with the highest light always on the principal figure? Why should panes recede in alternating light and shade? Throughout his long career, he remained faithful to the boldness of the Pre-Raphaelite Brotherhood's enterprise, as well as to its original religious idealism.

Born in London, the son of a warehouse manager, he struggled as a student until the comradeship of the Brotherhood ended his isolation. Then he was dubbed 'the Maniac' owing to his joviality. 'Hunt is jollier than ever, with a laugh which answers one's own like a grotto full of echoes,' wrote Dante Gabriel Rossetti, while another friend noted his sunny manner and looks, 'with a large square yellow beard [and] clear laughing blue eyes'.

According to William Rossetti, Holman Hunt was the one whom the other PRBs most 'thoroughly admired for his powers of art, his strenuous efforts, his vigorous personality'. His earliest paintings were inspired by literature and history. Then came *The Awakening Conscience* (1853–4), showing a remorseful fallen woman, and *The Light of the World* (1851–3), a world-famous image of Christ holding a lantern. Their success enabled him to travel to the Middle East to paint authentic biblical landscapes and people. He found it hard to meet Jewish people socially ('the Rabbis suspect me of being a missionary in disguise') and virtually impossible to obtain female models. From the Dead Sea, he brought back the strange *Scapegoat*, tales of adventure in the Judaean hills, and an Arab costume, in which he was photographed by Julia Margaret Cameron.

William Holman Hunt
David Wilkie Wynfield, 1863

A lighter side is conveyed in this costume portrait, one of Wynfield's sequence of 'Living Artists, Taken in the Style of the Old Masters', where Holman Hunt is shown in the manner of Holbein.

William Holman Hunt
Sir John Everett Millais, 1853

'Millais has done a pencil drawing of me, which is pronounced very like,' wrote Holman Hunt. 'It is totally different from all other sketches which my friends have done, being unlike a murderer or a beer-drinking pickpocket.' Drawn shortly before he left for Palestine, this portrait was exhibited at Russell Place in 1857 and kept by Millais until 1886, when he gave it to Edith Hunt.

Opposite:
William Holman Hunt
Sir William Blake Richmond, c.1897

In maturity, Holman Hunt took on a patriarchal appearance that seemed to link him with the biblical subjects and scenes of his art.

On his return to Britain, Holman Hunt exhibited at Russell Place, contributed to the illustrated Tennyson and met the younger generation of Pre-Raphaelites. Burne-Jones recorded 'a glorious day' in Rossetti's studio when Holman Hunt called: 'such a grand-looking fellow, such a splendour of a man'. While he was away, Holman Hunt had left Annie Miller, the young model he hoped to marry, in PRB care. Frederic Stephens handled her allowance and Millais painted her. But there were flirtations – Lizzie was furious with Rossetti – and eventually Holman Hunt abandoned his plan. Rejected by Cameron's niece Julia, in 1865 he married Fanny Waugh, whose sister was Thomas Woolner's wife. On honeymoon in Florence she posed for *Isabella and the Pot of Basil*, but sadly she died following the birth of a son. In 1873 Holman Hunt married her sister Edith, in defiance of English law and the Waugh family.

Later portraits convey his firm, even obstinate, temperament, but hint at vulnerability. Though often out of tune with the prevailing orthodoxy, he was proud to be a self-made Victorian. A member of the Hogarth Club, he remained a good friend to Stephens and William Rossetti (who was best man at his wedding), generous towards other artists like Edward Lear and John Brett and an active colleague of William Morris in the Society for the Protection of Ancient Buildings. Later paintings include *The Triumph of the Innocents* and *The Lady of Shalott*.

Towards the end of his life Holman Hunt felt he was a lone upholder of original PRB principles. In 1886 he composed the first account of the movement, and in 1905 published two volumes of autobiography which contested the Rossettian dominance of other PRB histories.

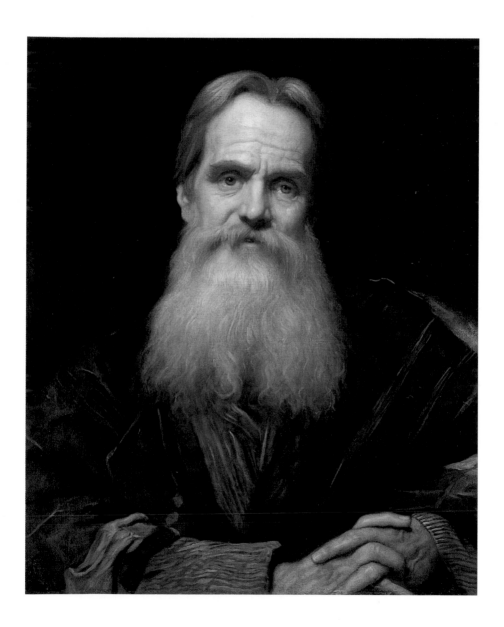

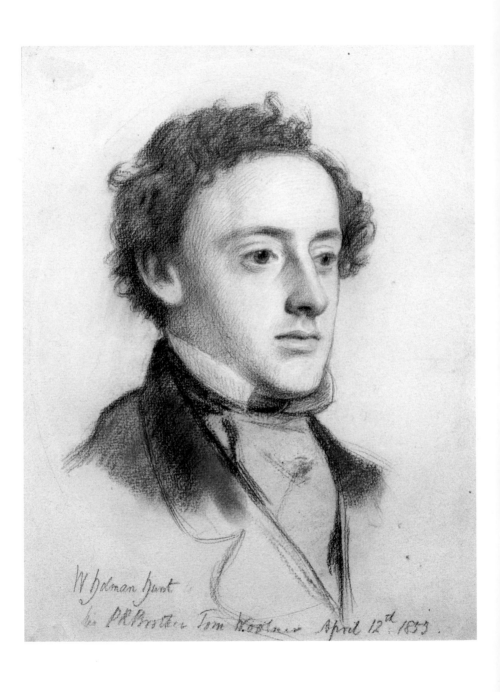

W Holman Hunt

to PR Brother Tom Woolner April 12th 1853.

John Everett Millais (1829–96)

Millais was a boy wonder, at eleven the youngest-ever student at the Royal Academy. 'He had a precocious capacity for both drawing and colouring,' recalled William Holman Hunt; 'not an hour of his life has been lost to his purpose of being a painter.' Although well able to succeed in conventional terms, he channelled his impatient ambition into the Pre-Raphaelite ideals. Relishing the challenge to his elders, he took the PRB commitment to honesty and sincere feeling further than anyone else.

His first PRB work, *Isabella* (1849) was well received, but *Christ in the Carpenter's Shop* (1850) was given a roasting. Charles Dickens famously attacked the depiction of Jesus as 'a hideous, wry-necked, blubbering red-haired boy in a night shirt'. But the hostility made the movement the talk of the season and Millais' future was secured. His next works, *Ophelia* (for which Elizabeth Siddal posed in a bathtub) and *A Huguenot* (both 1852), were intentionally more romantic. 'People had better buy my pictures now, when I am working for fame,' remarked Millais; 'later, I will be working for money.'

In 1852 John Ruskin became Millais' patron and mentor. The following year Millais accompanied the Ruskins on holiday in Scotland in order to paint Ruskin's portrait amid landscape. 'When the weather permits,' Millais wrote, 'we all dine out upon the rocks, Mrs Ruskin working [sewing], her husband drawing and myself painting; nothing could be more delightful.' In truth, he was so distressed by Ruskin's coldness towards his wife that he fell in love with Effie himself, and married her two years later.

Fellow artists were awed by his talent and charmed by his personality. Dickens's daughter Kate noted his 'extraordinary vivacity, and the keenness and delight he took in discussing plays, music, and sometimes

Sir John Everett Millais
William Holman Hunt, 1853

'He always looked so beautiful,' recalled Arthur Hughes; 'tall, slender, but strong, crowned with an ideal head and (as Rossetti said) "the face of an angel".' This portrait, drawn in 1853 for Thomas Woolner in Australia, depicts Millais at the height of his youthful renown. His aquiline features made him a popular portrait sitter, though his lively temperament prevented his posing for very long.

painting' while she was modelling for *The Black Brunswicker* (1860). 'So those sittings, which I had looked forward to with a certain amount of dread and dislike, became so pleasant to me that I was heartily sorry when they came to an end.'

Millais' personal taste was for scenes and landscapes of arrested, fragile beauty, such as the atmospheric *Autumn Leaves* (1856), which William Rossetti described as 'a tremendous piece of colour, mastery and that kind of poetic feeling which ... one recognises in the works of Titian or Giorgione'. Although he hoped that Millais would 'not lose himself in obvious, popular or frivolous subjects', the needs of a large family, long visits to Scotland and social distance from his former Brothers led precisely in this direction. 'A sorry sight indeed,' commented William Morris in 1884, 'of a ruined reputation, a wasted life, a genius bought and sold and thrown away.'

But this harsh judgement is tempered by recent reappraisals, especially of his paintings of children, which combine the truthfulness of Pre-Raphaelitism with aesthetic beauty of form and colour. He also produced a masterly body of illustration, ranging from Tennyson's poems to Trollope's novels. He was the perfect illustrator, according to Trollope, because 'in every figure that he drew it was his object to promote the views of the writer' rather than those of the artist. 'To see him has always been a pleasure,' added the novelist, and in middle life Millais' sociability, added to his pictorial fluency, brought a large portrait practice, including prime ministers Disraeli and Gladstone, Cardinal Newman, Lord Tennyson, Thomas Carlyle, and women such as painter Louise Jopling and professional beauty Lillie Langtry. Jopling recalled first meeting Millais at an exhibition in the company of Val Prinsep. 'Good show of Old Masters,' commented Val. 'Old Masters be

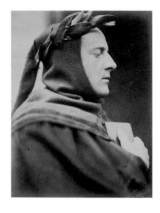

Sir John Everett Millais
David Wilkie Wynfield, 1860s

When Wynfield persuaded leading painters of the day to pose in period costume for his sequence 'Living Artists, Taken in the Style of the Old Masters', he chose to photograph Millais in the character of Dante – an allusion to the inspiration of the PRB and the sharp profiles of an early Italian portraiture.

John Everett Millais

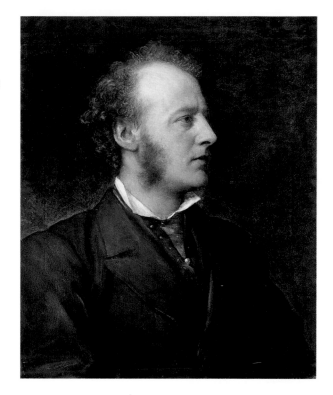

bothered!' replied Millais, winking at Jopling. 'I prefer the young Mistresses!'

In 1885 he became the first artist to be made a baronet and in the last months of his life he was elected President of the Royal Academy, whose judgements the Brotherhood had challenged nearly fifty years earlier. 'The Millais-nium of art has come: from PRB to PRA,' joked Holman Hunt. From angelic boy to grand old man.

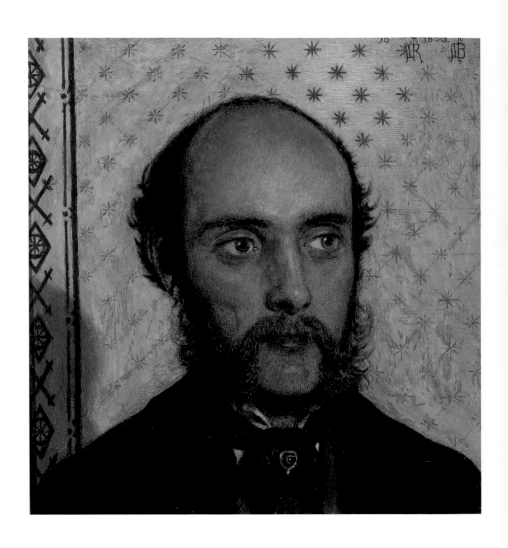

William Michael Rossetti (1829–1919)

The Pre-Raphaelite Brotherhood's official scribe, keeping the PRB Journal and also editing *The Germ*, William Michael Rossetti became the longest surviving member of the Brotherhood and its historian. His verses for *The Germ* outlined the movement's aims as he saw them: 'Be not too keen to cry/"So this is all?"' he wrote. 'Ask: "Is this truth?"' Truth remained his own sober watchword.

The third of the Rossetti siblings, William went to work at fifteen – 'a hard necessity and felt as such'. The camaraderie of the Brotherhood sustained his spirits and he tried his hand at both art and poetry, although he was always eclipsed by others. His brother's portrait – done in 1853 when the PRBs gathered at John Everett Millais' studio to draw each other in order to send the likenesses to Thomas Woolner in Australia – suggests William's reticent nature. Ford Madox Brown's portrait (opposite), painted one evening after work, invests him with more confidence, as art critic and valued friend. Sitting to Julia Margaret Cameron in cloak and beret a decade later, he has become the Victorian man of letters.

Being precise in manner, despite radical and atheistic views, he sometimes seemed pedantic and dull. William Morris called him a fool, but his measured judgements of character are singularly sound. 'One of the best informed and balanced minds I have had the luck to know,' noted William Bell Scott. As well as art criticism, he published editions of the English poets, wrote a biography of Shelley and promoted Walt Whitman. He remained a good friend of William Holman Hunt and Frederic Stephens, and was close to Algernon Swinburne, despite his irregular lifestyle; however, he broke all ties with Simeon Solomon when the latter was publicly disgraced.

William Michael Rossetti
Ford Madox Brown, 1856

This portrait was painted by gaslight one evening after William's return from a day in the office. His necktie is secured with a pin that had once belonged to Napoleon. The portrait was a gift to William's mother, who was at the time educating Lucy Madox Brown.

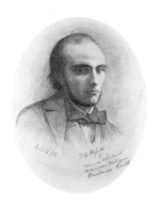

William Michael Rossetti
Dante Gabriel Rossetti,
12 April 1853

'His early misfortune of baldness may have rather affected his innermost feelings,' noted William's daughter Helen; 'tho' he did not speak about it, he cannot have liked losing all his hair at 19 or 20.'

'What return can I ever make now for all that my dear brother gave me so freely in the early days, at a time when it is still a mystery to me how he could manage to give at all?' Gabriel wrote when William married Lucy Madox Brown. 'W.R. is one of the men I most esteem,' added Lucy's father, 'and as we all know quite incapable of allowing anyone who is near him to be unhappy.'

William was an elderly father to his irreverent children, who nicknamed him 'Fofus' (funny old fusspot). In retirement, after fifty years in government service, he edited the family archive, reprinted *The Germ*, gently mediated in the quarrels that arose among his surviving Brothers as to the origins of the

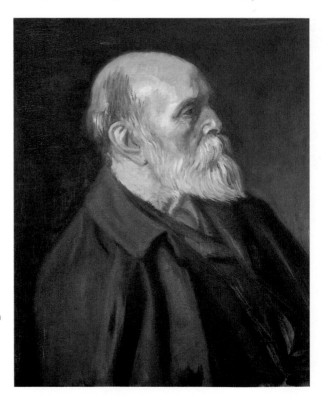

Right:
William Michael Rossetti
Sir William Rothenstein, *c*.1909

'Rothenstein came and took my portrait – lifesize head in oils. He is a rapid worker and between 11 and 4, with a full interval for lunch, he had about finished it,' recorded the sitter. 'It seems to us a fine likeness, with a more energetic expression than other recent versions.'

Algernon Charles Swinburne, Dante Gabriel Rossetti, Fanny Cornforth and William Michael Rossetti
Probably by William Downey, c.1863

Taken in the garden of Tudor House, Cheyne Walk, this unintentionally comic picture conveys the eccentric atmosphere of Rossetti's household in the 1860s. The garden was shared with various exotic animals, including a peacock, a raccoon and an armadillo.

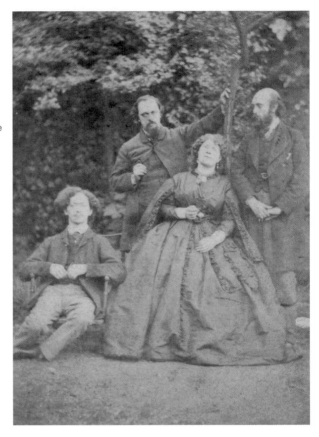

PRB and wrote his memoirs. Today, our knowledge of the early circle comes largely from his records and memories. 'Certain it is,' he observed, 'that few people living know, or ever knew, so much as I do.' To William Rothenstein, whose portrait shows him as a distinguished old gentleman (opposite), he was 'an admirable critic of literature and art; he had kept his faith in the power of art bright and clean; and his outlook on life was broad and humane ... to anyone who went to see him, he gave himself generously'.

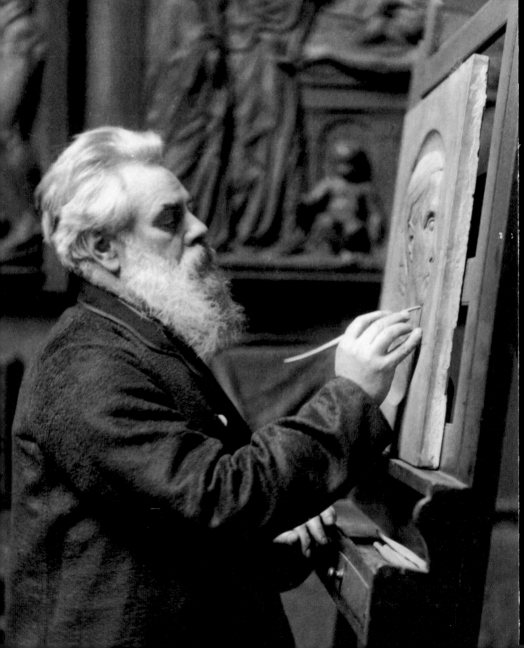

Thomas Woolner (1825–92)

The only sculptor in the Pre-Raphaelite Brotherhood, Woolner first came to notice with his depiction of Puck, showing the goblin-creature landing on a toadstool where a snake is about to devour a frog. He had a genial personality, full of gusto, according to William Rossetti, but was also 'a vigorous believer in himself and his performances'.

Born in Suffolk, Woolner studied at the Royal Academy Schools, where he struck up a rapport with Rossetti, equally full of 'burning ambition to do work of excelling truthfulness and strong poetic spirit'. He made an early portrait of Tennyson, and contributed a much-praised poem to *The Germ*, entitled 'My Beautiful Lady'. The verses drew poet William Allingham into the circle. 'Real love of nature and delicate truth of touch; with the quaint guild-mark so to speak of the P.R.B.,' he wrote.

In 1852 Woolner decided to follow the gold rush to Australia and the Brothers bade him farewell as he left 'plentifully stocked with corduroys, sou'westers, jerseys, firearms and belts full of little bags to hold the expected nuggets'. Eight months later the remaining Brothers gathered at Millais' studio to make portraits of each other to send to him (see pages 30, 38 top and 46). The next day a letter from Woolner was read aloud at the studio, where his friends met for breakfast. 'I could not and need not say all that we said and conjectured about you,' replied Rossetti. 'Are not Hunt's sketches wonderful? Good-bye, dear Tommaso – write as soon as you can and tell me all the news.'

In October 1853 Woolner returned. 'You see I am back in England again, restored to civilization,' he announced. 'I have not returned like a conquering hero, loaded with honours and with chariots of riches ... nor have I a huge beard, brawny limbs and weather-worn bronzed countenance.'

Thomas Woolner
Ralph Winwood Robinson,
20 August 1889

'His uncompromising habit of calling a spade a spade ... not less than his outspoken contempt for trivialities,' wrote Stephens, 'procured for Woolner not a few admirers and it must be admitted at least an equal number of foes.'

Thomas Woolner
Dante Gabriel Rossetti, 1852

'Can the year change, and I not
think of thee/With whom so
many changes of the year/So
many years were watched – our
love's degree/Alone the same?'
(Dante Gabriel Rossetti,
sonnet to Thomas Woolner,
9 February 1853.)

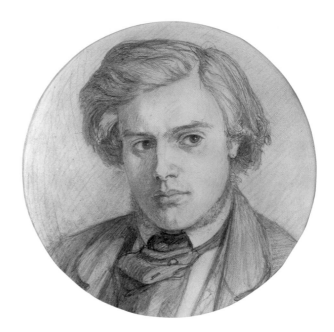

He resumed his career with a second medallion of
Tennyson (see page 13) and then a portrait bust,
followed by figures for the museum in Oxford. He
joined the Hogarth Club (and grew a beard) and was
photographed by Julia Margaret Cameron, but he
steadily moved away from the PRB circle, to pursue a
more conventional sculptural practice that led to his
election to the Royal Academy in 1875, where he was
professor of sculpture between 1877 and 1879.

In 1864 he married Alice Waugh, whose sister
Fanny married William Holman Hunt, but this close
link between the two Brothers was severed when the
widowed Holman Hunt married Edith Waugh, and
Woolner supported the family's objection. 'Gabriel of
late years hated him,' noted William Rossetti in 1884,
who himself remained on good terms with Woolner.
Frederic Stephens wrote his obituary.

Christina Rossetti (1830–94)

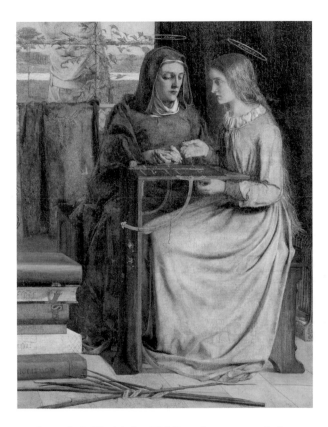

Author of *Goblin Market* (1862) and now regarded as one of the finest poets of the Victorian age, Christina Rossetti was engaged to James Collinson until he resigned from the Pre-Raphaelite Brotherhood, and her face features in her brother's earliest oils to carry the cryptic initials PRB – *The Girlhood of Mary Virgin* (1848–9) and *Ecce Ancilla Domini!* (1850). In the former, Dante Gabriel explained, Christina's appearance was 'excellently adapted to my purpose', while their mother sat for the figure of St Anne.

Born in London to a bilingual Anglo-Italian family, Christina was the youngest of four children, with a precocious talent for verse and a lively, even mischievous temperament. 'During her girlhood, one might readily have supposed she would develop into a woman of expansive heart, fond of society and diversion and taking a part in them of more than average brilliancy,' wrote William later, adding, 'what came to pass was of course quite the contrary'. While retaining an acute wit, Christina followed her older sister Maria into Anglo-Catholic piety and self-denial, which conflicted with her natural desire for poetic fame, expressed in elliptical, layered verses that conceal as much as they reveal, as in 'A Pause of Thought', first published in *The Germ*:

> I looked for that which is not, nor can be,
> And hope deferred made my heart sick, in truth;
> But years must pass before a hope of youth
> Is resigned utterly ...

In the late 1850s she worked at a home for 'fallen women', helping to reclaim young prostitutes, and from this emerged her masterpiece *Goblin Market*, a narrative fantasy of sin and sisterhood, morality, magic, seduction and redemption which made her name. Poetically, her rhythms, assonance and simple-seeming complexities profoundly influenced Algernon Swinburne's verse, though their themes could not be more different.

In later life she suffered from thyroid disease, which ravaged her looks, while sorrow and grief, especially over Dante Gabriel's mental collapse, gave a penitential cast to her outlook. This sombreness is surely seen in Dante Gabriel's late portrait of Christina with their mother, drawn while they were helping nurse him back to health in 1877 (opposite). When offered this work after her death in 1894, the

Christina Rossetti and her mother, Frances Rossetti
Dante Gabriel Rossetti, 1877

'You may have seen that I got a portrait of Christina, along with my dear loving old Mother, into the National Portrait Gallery,' wrote William Rossetti to Swinburne. 'Christina had to be there one day, as a matter of course: but I greatly applaud myself on having thus wafted in my Mother by a side wind.'

Christina Rossetti

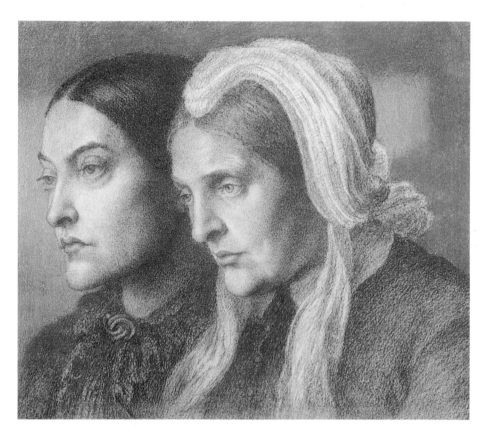

Trustees of the National Portrait Gallery unanimously agreed to waive the usual rule not to admit portraits of people who had died fewer than ten years before 'on account of her high eminence as a poetess in the literary history of this country'.

Frederic George Stephens (1828–1907)

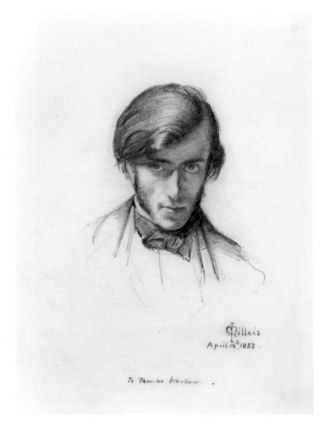

Frederic George Stephens
Sir John Everett Millais, 1853

This portrait was sent to Woolner and later given by him to Stephens's wife. In 1898 the sitter recalled the occasion: 'Unhappily for me, I was so ill at the time that it was with the greatest difficulty that I could drag myself to Gower Street.' Holman Stephens, the sitter's son, presented it to the National Portrait Gallery in 1929.

One of the original Pre-Raphaelite Brothers who later exchanged painting for writing, Stephens became a leading art critic, following in the footsteps, though without the prestige, of John Ruskin. For forty years, through continuing Pre-Raphaelite friendships, he kept the movement and its works in the public eye, and wrote several obituaries of the artists.

Born in London, he met John Everett Millais and William Holman Hunt at the Royal Academy Schools,

and was nominated for PRB membership by the latter, who befriended and mentored the less confident 'FGS'. Though lamed by a childhood accident, his features were considered 'markedly handsome' throughout his lifetime, and he served as model to both Millais, for Ferdinand in *Ferdinand lured by Ariel* (1849), and Madox Brown, for the figure of Jesus in *Jesus Washing Peter's Feet* (1852).

Millais' portrait of Stephens was drawn on the celebrated occasion in 1853 when the PRBs gathered at Millais' studio to draw each other in order to send the likenesses to Thomas Woolner, their absent Brother in Australia. Years later, Stephens wrote that it was 'a good deal out of drawing' – that is incorrectly rendered – but the awkward tilt of his head and upward gaze reflect that fact that, while being drawn, Stephens was himself attempting to sketch Millais; in the event he gave up and Holman Hunt took over, producing the excellent portrait on page 32.

By the late 1850s Stephens had given up painting and joined William Michael Rossetti in commentating on art. A founding member and secretary of the Hogarth Club, in 1861 he became art critic for the *Athenaeum*, the leading cultural weekly, subsequently contributing to virtually every issue until 1901 and often providing 'previews' of his colleagues' works in progress. His special championship of Rossetti led in his last years to a dispute with his oldest friend, Holman Hunt, over the origins of the Brotherhood.

Married in 1866, Stephens was the father of one son, named Holman. For many years he lived in Hammersmith Terrace, neighbour to May Morris and Emery Walker. 'One need not overstate his intellectual or other merits ... but he was a very warm friend of mine,' noted William Michael Rossetti, who himself composed Stephens's obituary.

Ford Madox Brown (1821–93)

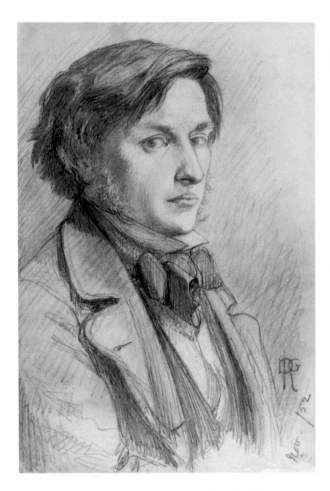

Ford Madox Brown
Dante Gabriel Rossetti, 1852

'The wisest and kindest of friends,' wrote Edward Burne-Jones; 'that irascible, quarrelsome old Brown was a very interesting fellow.' This early portrait was given to the National Portrait Gallery by William Rossetti in 1895.

Initially, Madox Brown felt the Pre-Raphaelite Brotherhood was rather a juvenile affair, but he was soon drawn in, contributing to *The Germ* and adopting the role of supportive elder brother to the group. 'The words Pre-Raphaelite Brotherhood or the letters P.R.B. used to be looked upon as ... childish or

ridiculous,' he wrote. 'But now, I can assure you I pronounce the words without hesitation ... the term will ... in the course of time gain a dignity which cannot fail to attach to whatever is connected with what they do.'

Trained in Antwerp and Paris, Madox Brown had more knowledge of European art than the PRBs. Having settled in Britain after the death of his first wife (mother to Lucy Madox Brown), in 1848 he met Dante Gabriel Rossetti; they remained the closest of friends. Madox Brown's earnest artistic beliefs gave definition to Pre-Raphaelite aims. 'Let the artist spare neither time nor labour,' he wrote, 'seeking to enter into the character of each actor [in a picture] studying them limb for limb, hand for hand, finger for finger ... shunning affectation and exaggeration and striving after pathos and purity of feeling, with patient endeavour and utter simplicity of heart.'

However, because John Ruskin disliked his work, and because he had a quarrelsome temperament that made him unable to please the public, his reputation lagged behind that of the others. In *The Last of England* (1855) he depicted himself and his second wife, Emma, as melancholy emigrants. Representing examples of contemporary labour, *Work* (1852–65) became his trademark picture, reflecting socio-moral ideas of the time. He organised the 1857 Russell Place show, became a founding member of the Hogarth Club and then a partner in Morris & Co., for which he designed furniture and stained glass.

With Emma, Madox Brown was a good friend to Elizabeth Siddal, and in 1860 he also intervened to hasten the Burne-Joneses' marriage. During the 1860s he became seriously sociable, hosting large parties and growing into his role as doyen of the circle. Links were strengthened when he became father-in-law to William Rossetti, but simultaneously weakened by his dispute with William Morris regarding the firm.

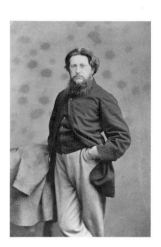

Ford Madox Brown
W. & D. Downey, early 1860s

A sympathetic teacher, Madox Brown fell rather in love while teaching Marie Spartali. 'It was Madox Brown who encouraged me to become an artist and taught me to paint and I can never feel sufficiently grateful,' wrote Marie Spartali.

William Allingham (1824–89)

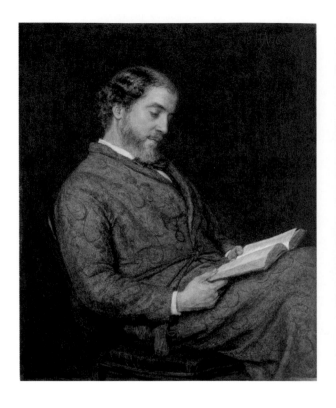

William Allingham
Helen Allingham, 1876

'You are one of the few valued
friends whom Lizzie and I have
in common,' Rossetti wrote to
Allingham in 1860. 'When shall
we be likely to see you again
in London?'

A close associate of the Pre-Raphaelite Brotherhood
in the early days, the young poet William Allingham
was forcefully attracted to their ideals. 'I remember
distinctly every breathing of the verses which were in
the first number of *The Germ*,' he recalled.

Born in Donegal and employed as a customs
officer, Allingham visited London annually, eagerly
joining in the Brotherhood's affairs and keeping
a journal that brings the circle to immediate life:
'Friday, July 19 [1850.] With Woolner, two Rossettis,
and Buchanan Reid in omnibus to Chelsea, to

Holman Hunt's lodging, large first-floor room looking on river ... much talk on pictures etc.; we have coffee and fruit; some lie on the floor, smoking ... As it was now late, and his guests showed no wish to depart, Hunt lay down on three chairs for a nap; but they only made merry of his drowsiness, proposed to sit on him etc., and so the time lounged on till dawn.'

Allingham's slim volume of poetry, published in 1855, contained woodcuts by John Everett Millais, Dante Gabriel Rossetti and Arthur Hughes. Rossetti's illustration was to 'The Maids of Elfen-mere':

> There came three damsels clothed in white
> With their spindles every night
> Two and one, and three fair maidens
> Spinning to a pulsing cadence
> Singing songs of Elfen-mere;
> Till the eleventh hour was toll'd
> Then departed through the wold ...

Rossetti's image kindled Edward Burne-Jones's desire to join the Pre-Raphaelites and led him to seek Rossetti through John Ruskin and Stephen Lushington at the Working Men's College.

Allingham was a guest at Red House, the Morrises' home in Kent, in 1864 (where Jenny and May Morris, aged three and two, were 'bright-eyed' and 'curly-pated') and often stayed with Rossetti at Cheyne Walk, until the household became too unruly for his comfort. His main pleasure was meeting and visiting Tennyson, whose conversation he recorded faithfully, hoping to become the Poet Laureate's biographer, and basking in reflected glory. In 1874 he married artist Helen Patterson, who under her married name became famous for her pictures of English country cottages.

Walter Howell Deverell (1827–54)

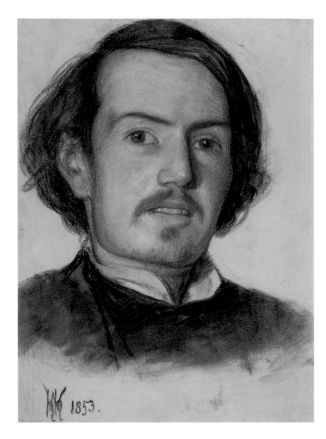

Walter Howell Deverell
William Holman Hunt, 1853

To Arthur Hughes, Deverell appeared 'a manly young fellow, with a feminine beauty added to his manliness, exquisite manners and a most affectionate disposition'. To William Bell Scott he was a 'morning-bright young Apollo'. Holman Hunt's portrait, drawn a few weeks before Deverell's death, shows both the attractive features that charmed his friends and the hectic colouring of sickness.

Walter Howell Deverell may be called a lost or missing Pre-Raphaelite Brother, owing both to his never-formalised election to the PRB in 1850, and to his untimely death at the age of twenty-six. Regarded as one of the liveliest and most talented young artists, he was involved in *The Germ*, modelled for William Holman Hunt, John Everett Millais and Ford Madox Brown, and introduced Elizabeth Siddal to the circle.

Born in Virginia, Deverell was brought up in London and studied at the Royal Academy Schools, where he met the Brothers-to-be, with whom he participated in a sketching club that preceded the PRB. He was especially close to Dante Gabriel Rossetti, who later made comic sketches of them both dealing with an eccentric patron.

Deverell also had literary tastes. Early in 1850 Elizabeth Siddal sat to Deverell for the figure of Viola in *Twelfth Night*. Rossetti had modelled for the figure of Feste, and also helped Deverell by painting in some of the hair. Deverell himself produced other works on Shakespearian themes, *The Irish Vagrants* (1853), a contemporary social subject, and two sweeter images of young women with pet birds. At the end of 1850 Frederic Stephens summoned the PRB to their anniversary New Year, telling Deverell, 'You must come and we will elect you into your proper chair.' However, this never happened, even though for a few weeks in 1851 Deverell and Rossetti shared a studio in Red Lion Square (later occupied by William Morris and Edward Burne-Jones).

In 1853 the death of his father left Deverell with heavy family responsibilities, which tied him to his teaching post at the School of Design in London and coincided with the onset of kidney disease. The PRB rallied round to assist financially and visited frequently. He died just as Millais arrived to see him. 'His was the happiest face when our circle sat together,' wrote Rossetti sadly to Thomas Woolner.

His memory lived on. In 1896 Burne-Jones bought his painting entitled *A Pet*, explaining that the artist was 'a poor handsome young fellow who died very young ... he occurs in several Pre-Raphaelite pictures and I think he's in that *Isabella* picture of Millais' with the man kicking the dog. A fine looking brown-headed youth he was.'

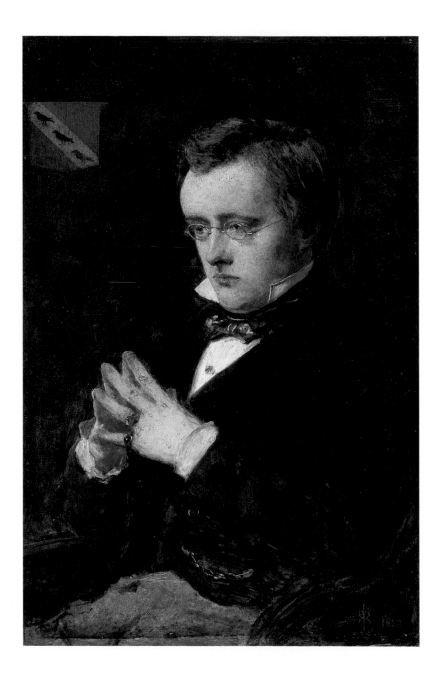

William Wilkie Collins (1824–89)

Novelist Wilkie Collins is best known as the author of *The Woman in White* (1860) and creator of the Victorian 'sensation' or suspense novel. A boon companion of Charles Dickens, he was also friendly with the Pre-Raphaelites, initially through his brother Charles Alston Collins, painter of the early Pre-Raphaelite work *Convent Thoughts* (1850). Their widowed mother, Harriet Collins, was a welcoming hostess to the young PRBs.

Wilkie and Charles Collins were especially close to John Everett Millais at the time of this portrait (opposite), which, according to William Holman Hunt, 'remained to the end of his days the best likeness' of Wilkie. Temperamentally Collins was restive, charming, warmly sociable, yet personally secretive. He was also, noted Holman Hunt, 'entirely without ambition to take a place in the competition of society, and avoided plans of life that necessitated the making up of his mind'. Later in life, like Holman Hunt, Collins grew a long and bushy beard, but always retained the same small spectacles.

Various elements from the Pre-Raphaelite world appear in Collins's fiction: for example, Professor Pesca in *The Woman in White* is closely modelled on the Rossettis' father. And the very plot of that novel, according to Millais, was inspired by an incident one night when he was walking home with the Collins brothers. Suddenly they heard a piercing cry. Then a garden gate was 'dashed open and from it came the figure of a young and very beautiful woman dressed in flowing white robes that shone in the moonlight. She seemed to float rather than run in their direction, and, on coming up to the three young men, she paused for a moment in an attitude of supplication and terror.' She then simply vanished into the shadows, followed by Wilkie, who did not return,

William Wilkie Collins
John Everett Millais, 1850

'He had a great bump on his forehead as depicted,' recalled Millais when the National Portrait Gallery acquired the portrait, adding, 'It is exactly what he was about the time he commenced his novel writing.' Showing the sitter in contemplative pose, perhaps devising the plot of his next story, this portrait only hints at Collins's lifelong dislike of formal dress, but successfully conveys his nervous energy – the man is like a coiled spring.

but later told his companions that she had been kept prisoner in the villa.

It is sometimes erroneously assumed that this was the plight of Caroline Graves, the first of Collins's unacknowledged lovers. The truth is more prosaic and pathetic: Collins set up in lodgings and supported for the rest of his life, but never publicly acknowledged, Caroline, a widowed mother, struggling to keep a small shop.

Though not close, Collins remained on friendly terms with the Pre-Raphaelite circle. 'Have you read Wilkie Collins's *Moonstone*?' Christina Rossetti asked Lucy Brown in 1881, when her brother was terminally ill. 'It was the last I read to poor Gabriel, and it interested us.'

Arthur Hughes (1832–1915)

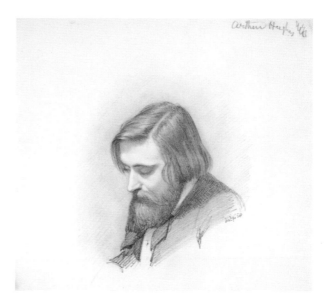

Arthur Hughes
John Brett, 1858

By this date, when both artists were members of the Hogarth Club, Hughes had grown the obligatory mid-Victorian beard. The portrait well conveys his self-effacing nature, and contrasts tellingly with Brett's forthright full-face presentation to the camera (see page 74).

Never in the centre of the circle but close to virtually all the main players, Arthur Hughes remained faithful to both the artistic principles and the sense of comradeship of the Pre-Raphaelite Brotherhood. He sat to John Everett Millais for the head of the cavalier in *The Proscribed Royalist* (1853), while his own best-known works, both displaying his trademark use of brilliant green and purple, are *April Love* (1856) and *The Long Engagement* (1859). Work outdoors on the latter was hindered, he told William Allingham, by dog roses that closed with every cloud, and an aggressive giant bee.

Born in London, Hughes studied at the Royal Academy and through Walter Deverell was introduced to the work of the PRB and *The Germ*, though he only met Dante Gabriel Rossetti in 1852 and John Everett Millais the year after, when both artists exhibited

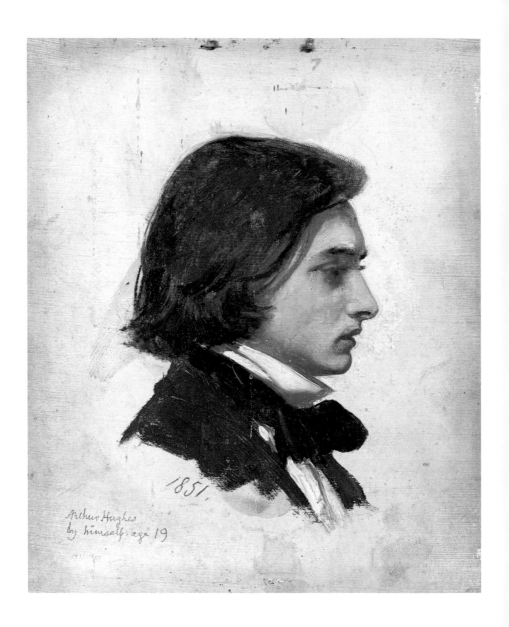

1851.

Arthur Hughes
by himself. age 19

Arthur Hughes

images of Ophelia. Millais' version far outshone Hughes's, in ways that set a pattern for his whole life; perhaps the high point came with John Ruskin's praise and William Morris's purchase of *April Love*. 'Go and nobble that picture as soon as possible lest anyone else should buy it,' Morris told Edward Burne-Jones. In 1857 Hughes participated in the Pre-Raphaelite show at Russell Place, and in the Oxford University decorating scheme, where he must have been the quietest companion. He was also a founder member of the Hogarth Club, and later in life he was a friend and guest of William Bell Scott at Penkill, the Scottish castle he shared with fellow painter Alice Boyd.

In character he had 'the most ingenuous nature of all,' wrote William Michael Rossetti, and was the freest from 'envy, hatred, malice and all uncharitableness'. This modesty and sweetness of temper may explain an overall lack of commercial success, as well as the way Hughes is overlooked in Pre-Raphaelite histories.

Among other illustrations – 'all of them excellent in many ways', according to Rossetti – Hughes drew the block for Allingham's famous poem 'The Fairies' in 1855, followed by work for Tennyson's *Enoch Arden* (1864), George Macdonald's *At the Back of the North Wind* (1871) and notably Christina Rossetti's collection of nursery poems, *Sing-Song* (1871), which delighted the author.

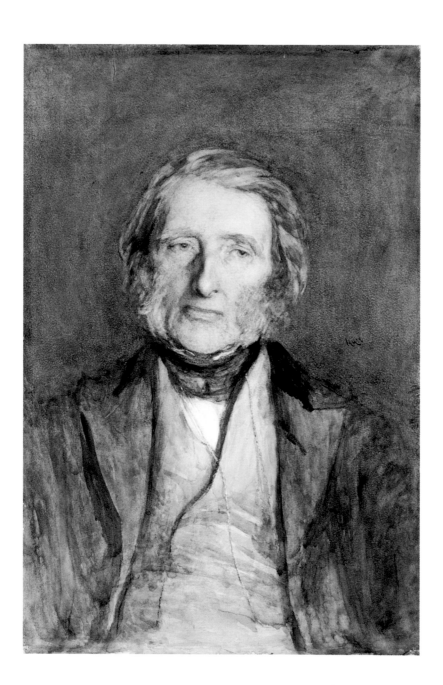

John Ruskin (1819–1900)

Ruskin became the first critic to defend Pre-Raphaelite aims in 1850, when he proclaimed that the works of John Everett Millais and William Holman Hunt were 'in finish of drawing and splendour of colour, the best in the Royal Academy' and would lay the foundations of an English school of art 'nobler than the world has seen for 300 years'. Thereafter he remained a staunch, if sometimes critical, supporter of the movement and a good friend to many, though not all, its members. Born in London, the son of a wealthy wine merchant, he was already known to the Pre-Raphaelite Brotherhood as the champion of Turner and author of *Modern Painters* (1843 and 1846). A generous if didactic patron, his first protégé was Millais, who in the summer of 1853 accompanied the Ruskins to Perthshire in order to paint his portrait in Glenfinlas. 'Ruskin and myself have just returned from a glorious walk along a rocky river near here,' reported Millais. 'I am going to paint him looking over the edge of a steep waterfall.'

As it turned out, the portrait was completed in London, although before then Effie Ruskin left her husband, having fallen in love with Millais, whom she married in 1855. Ruskin then transferred his patronage to Dante Gabriel Rossetti, Elizabeth Siddal, John Brett, Edward Burne-Jones and several more, whose practice he hoped would combine exact observation with transcendental truth. 'The noblest art is an exact union of the abstract value, with the imitative power, for forms and colours,' he wrote. During the 1850s he published an annual commentary on the year's art which frequently, though not exclusively, commended the Pre-Raphaelite circle.

A convinced defender of Gothic buildings and a meticulous draughtsman, he used his collection of geological and botanical specimens and architectural

John Ruskin
Sir Hubert von Herkomer, 1879

Slight in stature and fair in complexion, as a boy Ruskin was bitten on the cheek by a dog, which left a lifelong scar.

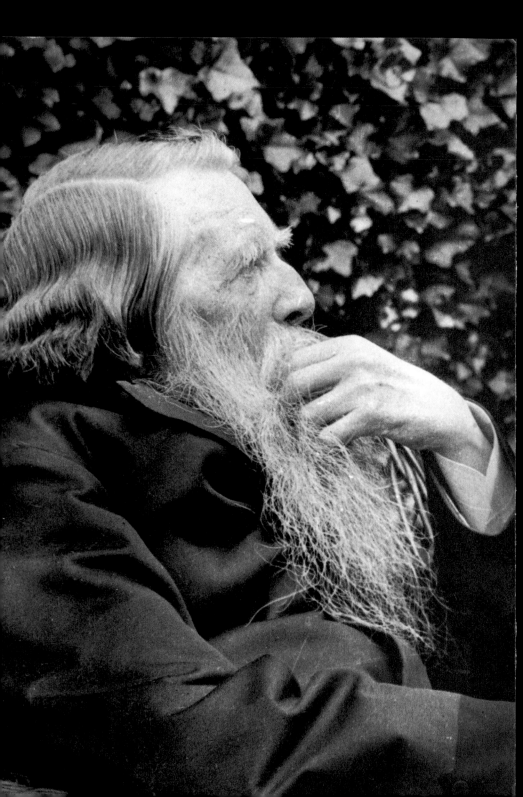

John Ruskin

John Ruskin
Sarah Acland, 1 August 1893

'[A] year or two before his death, I found him in his quiet Brantwood home – to look at just like Lear in the last scene,' wrote one of the last visitors to Ruskin's Lakeland house.

drawings to teach art at the Working Men's College in London, persuading Rossetti and Burne-Jones to join him. He also promoted the decoration of the Oxford University debating chamber. Protesting against the commercialism of the modern world, he then turned from art to social criticism, advocating the idea of an 'organic' society of unmechanised production and harmonious class relations. 'We want one man to be always thinking and another to be always working,' he complained; 'whereas the workman ought often to be thinking and the thinker often to be working.'

These ideas divided his Pre-Raphaelite friends. Who could read anything 'about such bosh'? asked Rossetti. But how 'deadly dull' the world would be without Ruskin, countered William Morris: 'It was through him that I learned to give form to my discontent.' Lamenting his own break with Ruskin, Burne-Jones recalled his profound gratitude to the critic's early encouragement.

In 1870 Ruskin was appointed Slade Professor of Art at Oxford University, where his lectures attracted large audiences. But he was already suffering from mental illness. In his last years his mind was permanently clouded and from 1889 he wrote nothing, although he was still revered as a sage and prophet. In the 1890s his essay 'On the Nature of Gothic' was republished by the Kelmscott Press, being in Morris's view 'one of the very few necessary and inevitable utterances of the century. To some of us ... it seemed to point out a new road on which the world should travel.'

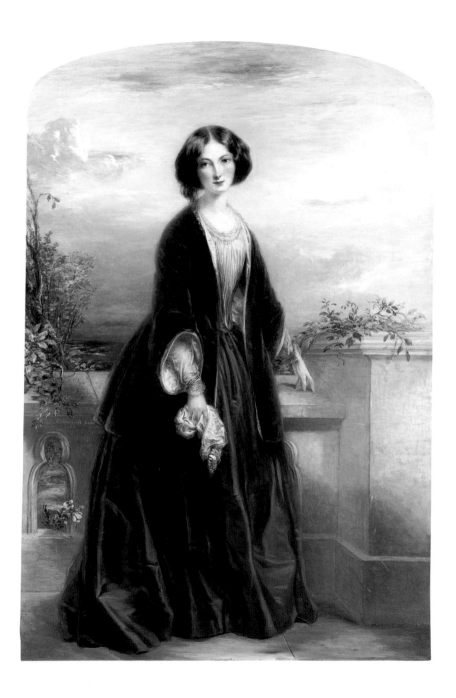

Euphemia Gray, later Millais (1828–97)

Euphemia ('Effie') Chalmers, Lady Millais
Herbert Watkins, late 1850s

Opposite:
Euphemia ('Effie') Chalmers, Lady Millais
Thomas Richmond, 1851

'It is the most lovely piece of oil painting, but much prettier than me,' Effie wrote when the portrait was exhibited at the Royal Academy. 'I look like a graceful doll, but John and his father are delighted with it.' When Effie left his son, Mr Ruskin senior, who had paid for the work in wine, deleted her name from the back of the picture and returned it to the artist.

It was as Mrs John Ruskin that Effie (as her first name was always rendered) first met members of the Pre-Raphaelite circle. Born in Perth, she married Ruskin in 1848 and travelled with him to Italy, spending some months in Venice. In Britain she was made unhappy by her husband's indifference and continuing dependence on his parents. When Ruskin extended his patronage to the Pre-Raphaelite Brotherhood, John Everett Millais painted Effie as the young Jacobite wife in *The Order of Release, 1746* (1852–3), and then accompanied the Ruskins to Scotland for a long, rainy trip during which he became eager to assist in her own release. Calling Effie 'the Countess', he drew many delicate portrait sketches. Effie subsequently left Ruskin and in July 1854 her unconsummated marriage was annulled. 'I am quite a different creature,' declared Effie soon after leaving Ruskin. 'I am naturally so happy that I am able to return to any pursuits with great delight.' A year later she married Millais at her parents' home in Perthshire.

At first Effie was involved in her husband's work, finding models and props and dealing with research and correspondence. In 1862 she also posed in a state bedroom at Knole for the figure of Madeleine in Millais' *The Eve of St Agnes*. But a large family – there were eight children – and mounting professional success led them away from the Pre-Raphaelites and into society. At the height of Millais' fame, they mixed with the Prince of Wales's circle. However, Effie was banned from court, where no woman with two living husbands was invited, and only after a deathbed plea from her husband was she received by Queen Victoria.

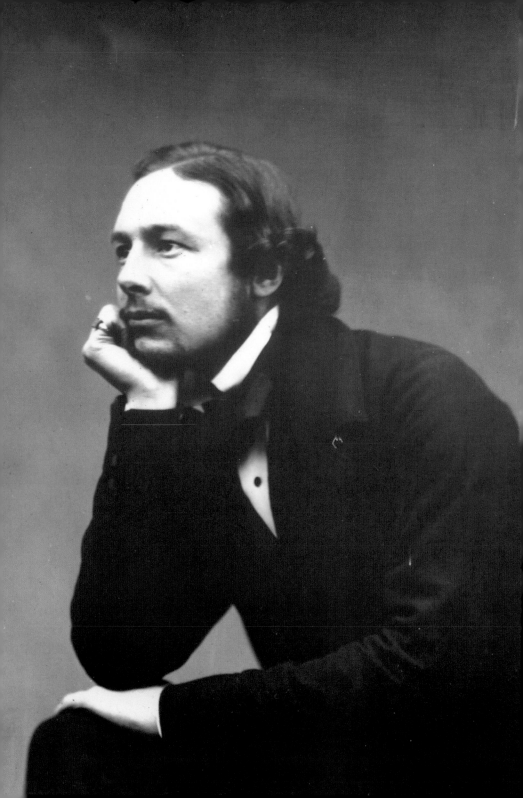

George Price Boyce (1826–97)

A dedicated if modest painter of landscapes and architectural subjects, Boyce is best known for his diaries, which give intimate glimpses into the Pre-Raphaelites' social life. Born in London, the brother of Joanna Boyce Wells, he took up painting after meeting the landscape artist David Cox. During the 1850s his friendship with Dante Gabriel Rossetti blossomed and by 1859 they were playful rivals for the favours of Fanny Cornforth, Annie Miller and other models. Rossetti drew a lively image of Fanny with her arms round Boyce's neck.

Artistically, Boyce was influenced by John Ruskin. His status as 'a confirmed Pre-Raphaelite' came with the 1857 Russell Place exhibition and membership of the Hogarth Club. Leading a sociable bachelor existence, Boyce dined regularly with Millais, Madox Brown and Scott. His diary records one evening spent 'at Swinburne's, taking with me as a contribution to his housekeeping 2 old blue and white dishes and a very fine Chinese plate ... Present: D.G. Rossetti, Whistler, Val Prinsep, Ned Jones and Sandys. Whistler gave humorous vent to a lot of comic stories. Walked away with Jones and Rossetti.'

As a landscapist, Boyce spent the summers travelling. In Britain his favourite subjects were old farm buildings amid trees, but he also drew London scenes. He 'finds the secret beauty of a dingy place,' wrote Frederic Stephens, making his pictures from 'a flash of smoky sunlight on a soot-grimed wall, a line of grimy, old red houses and the struggles of town foliage'. In 1862 Boyce took over Rossetti's former studio at Blackfriars (see page 17), then moved to a house in Chelsea designed by Philip Webb. With Webb and William Morris, he was an active member of the Society for the Protection of Ancient Buildings. Stephens wrote his obituary for the *Athenaeum*.

George Price Boyce
Unknown photographer, early 1860s

'I think you & I are among the most lastlingly get-on-ables,' Rossetti wrote to Boyce in 1862.

Joanna Boyce Wells (1831–61)

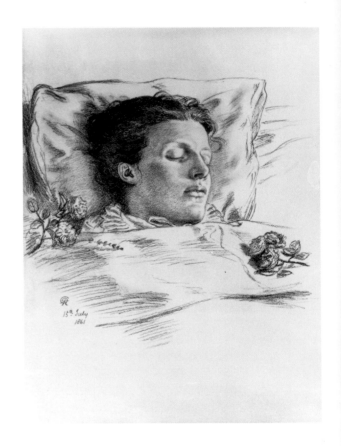

Joanna Boyce Wells
Dante Gabriel Rossetti,
15 July 1861

It was a common Victorian practice to take a deathbed portrait of a loved one, especially when no recent photographs existed. When she died, Wells's husband, Henry, who knew Rossetti from student days, sent an urgent message asking him to come and draw a final, very poignant, likeness. Six months later, Rossetti's own wife, Elizabeth Siddal, would also be dead.

The foremost woman artist of her generation, in her short lifetime Wells was set fair to outshine her male colleagues. Close to the Pre-Raphaelite circle through her brother George Boyce and her husband Henry Wells, she also studied and travelled more widely, until marriage and motherhood curtailed her movements.

Born in London, she shared the original aspirations of the Pre-Raphaelite Brotherhood to paint carefully and honestly. 'Genius is in truth

nothing but a strong desire of knowledge,' she wrote; 'and the spirit of industry is its truest mark.' She was determined to overcome the obstacles facing women, declaring in 1854 that 'a passionate desire and an unwearied self can perform impossibilities ... if we ... go on, some unseen path will open among the hills'.

Her exhibition debut at the Royal Academy in 1855, with a widely praised depiction of Elgiva, an Anglo-Saxon noblewoman, brought Wells to public attention. Later the same year she studied with Thomas Couture in Paris, and wrote on art for the *Saturday Review*, declaring that 'the Pre-Raphaelite movement has done some good and will do more ... [teaching us] that an artist's strength lies in a child-like sincerity and in the shunning of pride'.

In 1857 she travelled through France and Spain to Italy with a group of friends, including fellow artist Henry Wells, whom she married at the end of the year. Despite children following in quick succession, she continued to work and exhibit, with pictures like *The Children's Crusade* (1860), *The Heather-gatherer* and *La Veneziana* (both 1861) at the Royal Academy. They were 'first-rate', according to Dante Gabriel Rossetti, while his brother, citing her name among others, noted how 'the second stage [of Pre-Raphaelitism] is rapidly coming on – of more masterliness, stronger style. More painterlike conception and energy.'

Two months later, Joanna Wells died following the birth of her third child. It was dreadful news, wrote Elizabeth Siddal, noting that she must have been 'the head of the firm' that was the Wellses' artistic partnership. There was no limit 'to what this wonderfully gifted woman would not have reached in her Art', added Rossetti; 'and in private life her greatness and goodness were no less rare'.

Despite the recognition, she subsequently faded from view, until feminist attention turned to women's work in the 1970s and 1980s.

Joanna Boyce Wells
Dante Gabriel Rossetti

This illustration is taken from a photograph of the original sketch given to the sitter's husband, which was destroyed in the Second World War.

Elizabeth Siddal (1829–62)

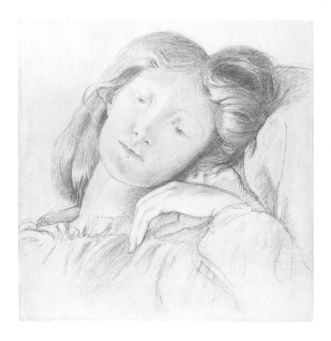

Elizabeth Siddal
Dante Gabriel Rossetti, 1860

'Her complexion looked as if
a rose-tint lay beneath the skin
... her eyes were of a kind of
golden brown – agate-colour is
the only word I can find,' recalled
Georgiana Burne-Jones; 'her
eyelids were deep ... and had
the peculiarity of seeming
scarcely to veil the light in her
eyes when looking down.'

Best remembered as the model for John Everett
Millais' painting of Ophelia (1851–2) and as
Rossetti's beloved, Elizabeth or Lizzie Siddal was
virtually unknown to the public during her short life,
but thereafter she became a Pre-Raphaelite icon and
figure of fascination and fantasy. Her own artistic
career was until recently overshadowed.

Born in London, the daughter of a cutler and
shopkeeper from Sheffield, she is said to have been
working as a milliner when asked to model for Walter
Deverell. She also posed for William Holman Hunt
and for Millais – in a bathtub of slowly cooling water
– before becoming Dante Gabriel Rossetti's student
and sweetheart. His many delicate portrait drawings
created her image as mistress and muse. Although to

Elizabeth Siddal with Dante Gabriel Rossetti
After an original pen-and-ink drawing by Dante Gabriel Rossetti, 1853

'Come back, dear Liz, and, looking wise, In that arm-chair which suits your size, Through some fresh drawing scrape a hole ...' wrote Rossetti on St Valentine's Day, 1856, when Lizzie was in Nice for the sake of her health.

William Allingham she was 'never beautiful', her pale skin, 'abundant red hair and long thin limbs were strange and affecting'.

Support from Dante Gabriel Rossetti, Ford Madox Brown and John Ruskin, who provided financial aid, enabled Siddal to pursue an artistic career, and she participated in the 1857 Pre-Raphaelite exhibition in Russell Place. Her pictorial work displays a self-consciously naïve technique, with intense and romantic emotion, expressed in subjects drawn from Tennyson and traditional balladry.

With her belated marriage to Rossetti in 1860, Siddal entered the heart of the circle, getting to know Georgiana Burne-Jones and Jane Morris. Algernon Swinburne – who shared the same red hair – was a warm friend. Sadly, however, her dependence on laudanum increased after the birth of a stillborn daughter in 1861 and the following February she died of an overdose. Distraught, Rossetti placed his unpublished poems in her coffin, only to retrieve them seven years later – an act posterity has neither forgotten nor forgiven.

When Pre-Raphaelite history began to be written, Siddal featured as sweet and pathetic 'dove divine'. Later commentators, augmenting sparse fact with vivid imaginations, placed her among the many women Rossetti seduced and betrayed. In the 1970s and 1980s feminist historians began to tell a different tale, considering her among the female artists of her age. Two exhibitions in 1991 illustrated her dual reputation: one comprised all Rossetti's drawings of her and the other was the first solo show of her own works.

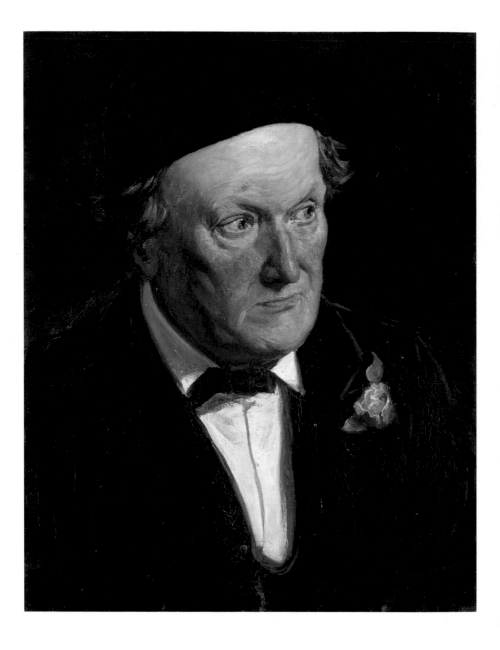

William Bell Scott (1811–90)

A somewhat prickly though likeable man, Scott became friends with members of the Pre-Raphaelite Brotherhood at the time of its formation and contributed to *The Germ*. Nicknamed 'Scotus' and often teased, especially after he went bald and began wearing a wig, he was particularly close to the Rossetti family. 'My old admiration before I was twenty/Is predilect still, now promoted to se[v]enty', Christina wrote later in allusion to their long acquaintance.

Born in Edinburgh, Scott trained as an engraver and illustrator before moving to London to pursue art, but from 1843 to 1863 was director of the School of Design in Newcastle-upon-Tyne. He visited London annually to keep up with friends.

'I have seen most of my lot since returning to town,' he reported on one occasion: 'Hunt, who seems stranded; Woolner, well off for commissions; ... [Burne-] Jones, looking more settled in health; Allingham, in hopes of getting permanently transferred to London; Morris, the recipient of two [Great] Exhibition medals for the Firm; Swinburne, who after introducing into his *Spectator* reviews imaginary quotations from phantasmal French poets of the dishevelled class, has now actually taken to writing entire reviews of these nonentities, much to his present chuckling.'

In 1859, though long married, Scott fell in love with Alice Boyd, an aspiring artist whose brother owned a small castle at Penkill in Ayrshire. This Alice later shared with Scott as a summer residence, and decorated in archaic style, with old furniture, heavy embroideries made by William Morris and a staircase mural into which Scott painted Christina Rossetti as a medieval lady. Alice spent the winters *à trois* with William and Letitia Scott in London.

William Bell Scott
Frederick Bacon Barwell, 1877

This portrait was painted in early autumn 1877, when the artist was a guest at Penkill. It shows Scott in later life, but still with the intense, almost malevolent expression that people in Italy identified as 'the evil eye'.

John Brett (1831–1902)

An artist famous for brightly depicted views and seascapes that are central to all studies of Pre-Raphaelite landscape, Brett was influenced by John Ruskin's writings and the works of the Pre-Raphaelite Brotherhood, whose circle he, together with his artist sister Rosa, joined for a while. His photograph, with its bushy whiskers and brows, suggests the forthright, uncompromising nature that kept him somewhat apart from the group.

While studying at the Royal Academy Schools, Brett met William Holman Hunt. Then, guided by Ruskin's essay 'On Mountain Beauty', in Switzerland

John Brett
Unknown photographer, 1880s

'I never said I loved you,
John ... /I'd rather answer
"No" to fifty Johns/Than answer
"Yes" to you.' (Christina Rossetti,
'No, Thank You, John!')

in 1856 he determined 'in a reasonable way to paint all I could see'. Holman Hunt and the Rossettis were impressed with his *Glacier of Rosenlaui* (1856) and at once recruited Brett to the 1857 Russell Place show. His work was commended by Coventry Patmore for its Pre-Raphaelite hallmark – the 'simple and sincere endeavour to render genuine and independent impressions of nature'. In 1858 Ruskin praised his *Stonebreaker* as 'simply the most perfect piece of painting'.

When Ruskin urged him to paint chestnut groves in the Val d'Aosta, Brett dutifully travelled there, returning with a masterpiece of Pre-Raphaelite landscape. He was naturally dismayed when his patron commended the scene, but damned the artist as an 'emotionless' recorder: 'I never saw the mirror so held up to Nature – but it is mirror's work, not Man's.' John Everett Millais concurred, describing the painting as 'a wretched work like a photograph'.

Although he joined the Hogarth Club, Brett's Pre-Raphaelite friendships began to cool, perhaps also because of his rejection by Christina Rossetti, with whom he was 'somewhat smitten'. Later, her brother Gabriel described Brett as 'insufferable'. By the mid 1860s he was carving out a new role as a marine and coastal painter; thereafter he spent much of the year travelling around the British Isles and the Mediterranean in search of subjects and pursuing scientific interests in astronomy.

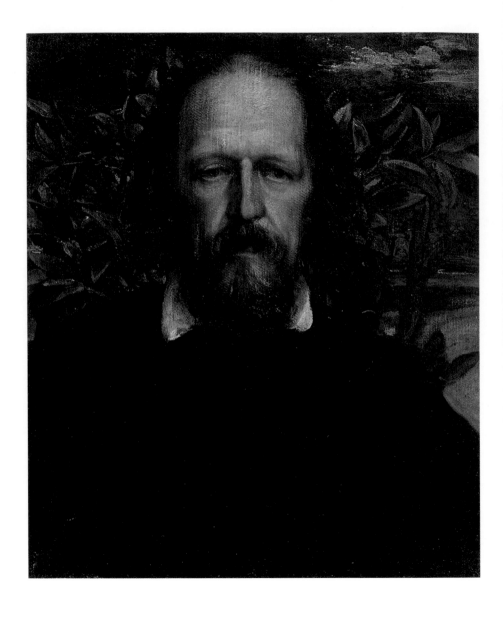

Alfred, Lord Tennyson (1809–92)

The most popular poet of the Victorian age and Poet Laureate from 1850, Alfred Tennyson was author of *In Memoriam* (1850), a long elegy for a dead friend, the epic retelling of the tales of King Arthur in *Idylls of the King* (1859) and ballads like *The Lady of Shalott* (1833). Many Pre-Raphaelite paintings were inspired by his poems. 'From my earliest days I have been a worshipper of his works,' recalled John Everett Millais.

Listed among the 'Immortals' admired by the Pre-Raphaelite Brotherhood and personally acquainted with most of the original circle, Tennyson was made an honorary member of the Hogarth Club in 1858. The year before, wood engravings by William Holman Hunt, Millais and Dante Gabriel Rossetti were included in an illustrated edition of his early poems. 'Tennyson loathes mine,' Rossetti told William Morris, but the poet took special exception to Holman Hunt's "Lady of Shalott". Where did the poem say her hair 'was flying all over the shop'? But, replied Holman Hunt, he had only one image to convey the 'weird fate' of the poem, not fifteen pages of verse. Tennyson also criticised the unseasonable juxtaposition of dog roses and daffodils in Millais' *Ophelia*.

One evening in 1855 at the Brownings' house when Tennyson read his poem *Maud*, Rossetti took the opportunity for a quick ink sketch. A more romantic image was produced by Thomas Woolner, whose medallion portrait of 1856 (see page 13) was used as frontispiece to the edition of the Laureate's poems illustrated by members of the PRB, reinforcing the links between poet and painters.

William Allingham was Tennyson's most faithful admirer and assiduous chronicler, vying with Julia Margaret Cameron, the poet's neighbour on the Isle of Wight, for conversations with the great man. Cameron produced the most memorable images in

**Alfred Tennyson,
1st Baron Tennyson**
George Frederic Watts, *c.*1863–4

'He is very swarthy and scraggy, and strikes one at first as much less handsome than his photos,' wrote Henry James. 'But gradually you see that it's a face of genius.'

Alfred Tennyson,
1st Baron Tennyson
Julia Margaret Cameron, 1869

'A tall, broad-shouldered swarthy man slightly stooping, with loose dark hair and beard ... he was a strange and almost spectral figure,' recorded Allingham.

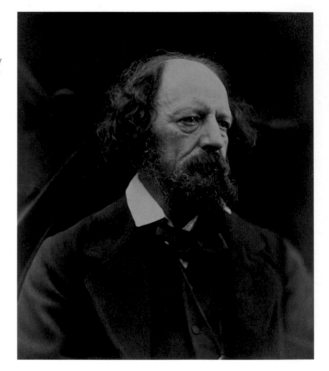

her photographs. One, Tennyson complained, made him look like 'a dirty monk'.

Millais painted his portrait in 1881, one of his sequence of eminent men. 'At one time I knew Tennyson well,' he recalled, adding that 'without immodesty' his was the best portrait of all. Again Tennyson was displeased, saying, 'It has neither brain nor a soul, and I have both.'

Julia Margaret Cameron (1815–79)

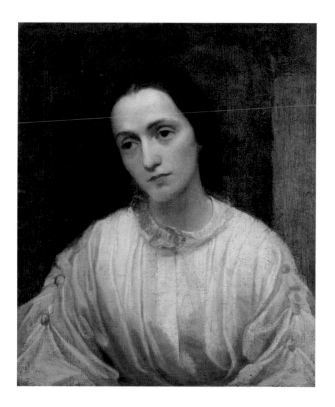

Julia Margaret Cameron
George Frederic Watts, 1850–52

Cameron was the least favoured
of seven sisters renowned for
their beauty. In this portrait
Watts seems to have blended
their looks into hers and given
her an uncharacteristic repose.
'I aim to paint ideas, not things,'
he declared.

When Cameron discovered the delights of
photography in middle age, she was already close
to the heart of the artistic circle at her sister's home
Little Holland House, west London, where George
Frederic Watts was resident genius. From the start her
work was imaginatively conceptual rather than
documentary in nature, and one early photograph
was called 'A Pre-Raphaelite Study' in tribute to the
movement. Others portrayed the close-up female
head in soft focus, echoing the painters' depictions
of sensuous beauty – the so-called 'stunners' of the

Julia Margaret Cameron
Henry Herschel Hay Cameron,
1870

Cameron named her youngest
son after the eminent
astronomer, who also translated
Homer. 'I wish you could write in
a special metre a Divine Poem
on Photography,' she wrote to
Herschel in 1867; 'and what the
sun does to us in one Instant of
Time – the imperishable Treasure
of a faithful Portrait ...'

1860s. These contributed to her main endeavour – to make art portraits of famous men and lovely women in ways that captured their greatness and beauty.

Born in India, Cameron was mother of six children when her career began. The technical aspects of photography, coupled with her obsession, sometimes made her a figure of fun, as she came down to dinner with hands blackened by chemicals, or bullied friends, relatives and strangers to don costumes and stand still for her lens.

In 1867 William Allingham met her returning to her home (near to the Tennysons') on the Isle of Wight. 'Down train comes in with Mrs Cameron, queenly in a carriage by herself, surrounded by photographs ... talking all the time,' he recorded, quoting her words. '"I want to do a large photograph of Tennyson and he objects! Says I make bags under his eyes – and Carlyle refuses to give me a sitting – says it's a kind of Inferno! The greatest men of the age [including Watts] say I have immortalised them – and these other men object!! What is one to do – Hm?"'

Rossetti evaded her attempts to immortalise him, but she did capture three PRBs: William Holman Hunt, Thomas Woolner and William Michael Rossetti – who described her work as 'surprising and magnificently pictorial'. She also made several portraits of Watts (see page 82) and Tennyson (see page 78), who jokingly reproached her, 'I can't be anonymous, because of your confounded photographs!' She made the first likenesses of Marie Spartali (later Stillman; see page 110) and took superb pictures of the young Ellen Terry. Other sitters included her nephew Val Prinsep in Tudor costume (nicknamed 'our royal cousin') and niece Julia Jackson, who passed on her Pre-Raphaelite looks to her daughter Virginia (later Woolf).

Julia Margaret Cameron

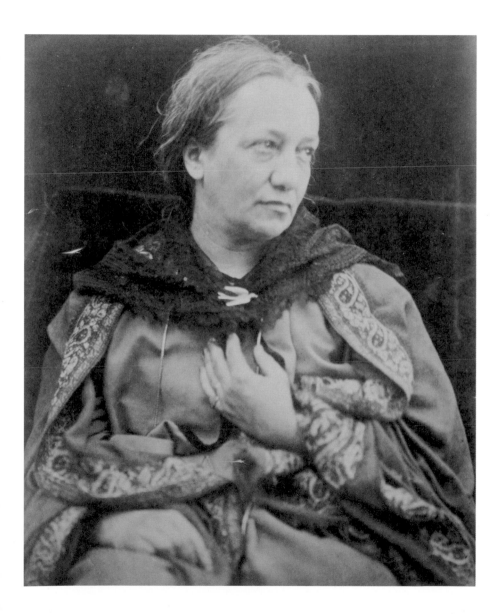

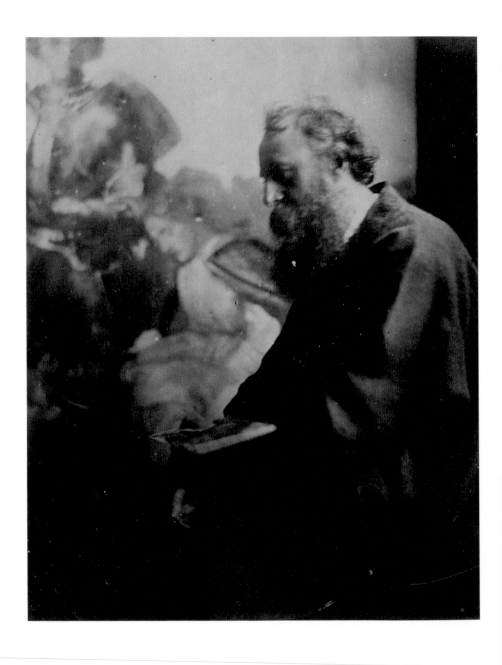

George Frederic Watts (1817–1904)

Regarded by the Victorians as the major painter of the age, Watts was not himself a Pre-Raphaelite, though he admired their work, and the Brotherhood held him in high esteem. They mixed in the same social circle, centred on Little Holland House in west London, and when Watts embarked on his 'Hall of Fame', a portrait series of eminent men – thirty-six of which are in the National Portrait Gallery – William Holman Hunt, Dante Gabriel Rossetti, William Morris, Edward Burne-Jones and Algernon Swinburne were included.

Born in London, Watts studied at the Royal Academy Schools and then in Italy, returning to Britain in 1847 full of schemes for grand public murals and political portraiture. Some early paintings were on social themes – the plight of garment-makers and fallen women – while others reflect his high idealism: 'Art must have a mission,' he said.

Slight in build, with finely cut features, Watts was nicknamed 'Il Signor', owing to a marked resemblance to Titian. From 1854 he lived with Sara and Thoby Prinsep at Little Holland House. His pupils included John Roddam Spencer Stanhope and Val Prinsep. His large mural for Lincoln's Inn, completed in 1859 and depicting lawmakers down the ages included heads based on Tennyson, Spencer Stanhope and Holman Hunt. 'I smuggled myself in at last to see that great work,' Rossetti told Julia Margaret Cameron's sister Sophia. 'Will you give the Signor my share of the thanks that everyone owes him?'

In 1864 Watts misguidedly married sixteen-year-old Ellen Terry, thinking to save her from the immorality of the theatre. The marriage was short-lived, and later Watts married another younger woman, Mary Seton Fraser, who proved a better helpmeet.

George Frederic Watts
Julia Margaret Cameron,
c.1863–8

'One day Gabriel took me out in a cab – it was a day he was rich so we went in a hansom and we drove and drove until I thought we should arrive at the setting sun,' recalled Burne-Jones; 'and he said, "You must know these people, Ned ... you will see a painter there, he paints a queer sort of pictures about God and Creation."'

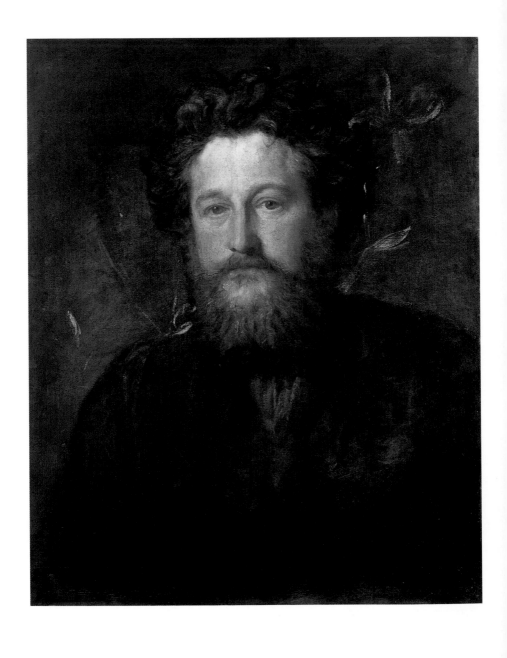

William Morris (1834–96)

The most restless and inventive of the whole Pre-Raphaelite circle, Morris began as a poet, took up architecture, turned to painting, returned to poetry, and found his vocation as designer, fine craftsman and socialist campaigner for a fulfilled life of pleasurable work. 'In spite of all the success I have had, I have not failed to be conscious that the art I have been helping to produce would fall with the death of a few of us,' he wrote. 'Art cannot have a real life and growth under the present system of commercialism and profit-mongering.'

Born in Essex, the son of a City broker, Morris developed his boyhood medievalism at Oxford, where he made lifelong friends with Edward Burne-Jones and Philip Webb. In 1856 they met Dante Gabriel Rossetti, Ford Madox Brown, John Ruskin and William Holman Hunt, and took the studio in Red Lion Square formerly shared by Walter Deverell and Rossetti, who declared them the 'finest young fellows in Dreamland'. Known to close friends as 'Topsy', probably because he 'just growed', Morris was much teased for his appetite, his expanding girth and his explosive temper, as well as for his disregard of dress and appearance.

From 1860 Morris's home, Red House in Kent, became a social centre for the circle, and here the firm known as Morris & Co. was founded. 'All the minor arts were in a state of complete degradation,' he explained; 'and with the conceited courage of a young man I set myself to reforming all that.' Textiles, furniture, glassware, wallpaper, tiles and stained glass were produced.

Later, firm and family moved to Queen Square in Bloomsbury, where Morris also practised calligraphy and illumination, and began dyeing with natural ingredients. 'Have nothing in your houses that you do

William Morris
George Frederic Watts, 1870

'I am going to sit to Watts this afternoon, though I have got a devil of a cold-in-the-head, which don't make it very suitable,' Morris wrote to Jane on 15 April 1870. Of the result, however, G.K. Chesterton declared that the way 'the living, leonine head' projects from green and silver decoration was apt, since 'the immersion of a singularly full-blooded and aggressive man in the minutiae of aesthetics is the paradox that attracted men to Morris'.

not know to be useful or believe to be beautiful,' he told customers.

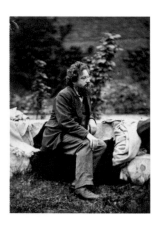

William Morris at the Grange, North End Lane, Fulham
Frederick Hollyer, 1874

'It wouldn't trouble him if you didn't like him, and he wouldn't say or unsay a thing to please you,' recalled Burne-Jones. 'If anything he might be likely enough to say a thing to startle you.'

Best known as a poet, author of the multi-volumed *Earthly Paradise* (1868–70), he went on to translate Norse sagas, partly as a diversion from the unhappiness of his personal life during the love affair between his wife, Jane, and Dante Gabriel Rossetti. From 1871 to 1874 Morris shared with Rossetti the tenancy of Kelmscott Manor in Oxfordshire, a secluded lovers' retreat that later became the Morrises' much-loved home in the country.

Active in Liberal affairs from the late 1870s, and by this date owner of a successful business, Morris founded the Society for the Protection of Ancient Buildings to promote architectural conservation. He also moved politically to the left to join the socialist movement of Marx and Engels, in 1890 writing *News from Nowhere*, a utopian romance describing his ideal society.

His last great project involved both typography and fine printing, in his own Kelmscott Press, undertaken with support from Emery Walker. For the Kelmscott 'Chaucer', Morris designed the page layouts, together with decorative borders to hold Burne-Jones's illustrations.

Jane Morris (1839–1914)

'Beauty like hers is genius,' wrote Dante Gabriel
Rossetti of Jane Morris, the woman whose image
filled his later paintings in iconic splendour. Henry
James was equally impressed. 'It's hard to say
whether she's a grand synthesis of all Pre-Raphaelite
pictures ever made – or they a "keen analysis" of
her,' he wrote. 'In either case she is a wonder.'
Pre-Raphaelite tastes had changed ideas of feminine
beauty, for Jane's dark hair and sombre, almost
melancholy looks were far from the Victorian
peaches-and-cream ideal.

Born in Oxford, the daughter of a stableman, Jane
Burden was seventeen when 'discovered' by Rossetti
and Burne-Jones, while they were decorating the
debating chamber at Oxford University, and
persuaded to model for Queen Guinevere and La
Belle Iseult. When Rossetti left to join Elizabeth
Siddal, Jane continued to pose for William Morris,
who is said to have written, 'I cannot paint you, but
I love you.' In 1859 they married and soon after
settled at Red House, where their daughters, Jenny
and May, were born. From the start Jane took an
active part in the work of Morris & Co., together
with her sister Bessie. Both women were eminent
embroiderers who, as well as producing fine pieces,
supervised the firm's other needlewomen.

By 1868, when the Morris family were living in
Queen Square, Janey was sitting regularly to Rossetti,
whose admiration grew into obsession. 'Famed for her
poet husband and surpassingly famous for her beauty,
now let her gain lasting fame by my painting,' he
wrote on her portrait – a wish that came true, for Jane
is today best known through Rossetti's images. She
returned his feelings and in 1871 Morris and Rossetti
took a joint lease on Kelmscott Manor so that Jane
and Rossetti might be together. They spent an idyllic

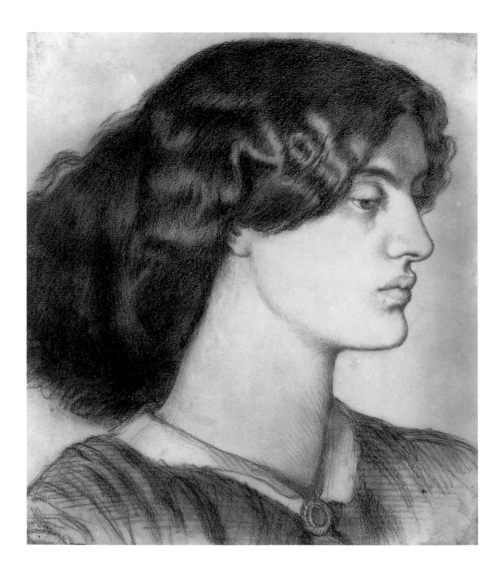

Jane Morris

Jane Morris
Dante Gabriel Rossetti, c.1865

'I consider this portrait one of the very best D.G. Rossetti did of me,' wrote Jane on the back of this drawing. Over forty others survive, together with countless sketches of her as Pandora, Proserpine (see page 21), Beatrice and similar subjects.

summer there while Morris went to Iceland. Rossetti composed a sequence of love sonnets in Jane's honour. 'Beauty like hers is genius,' wrote Rossetti:

Not in spring's or summer's sweet footfall
More gathered gifts exuberant life bequeathes
Than doth this sovereign face, whose love-spell
 breathes
Even from its shadowed contour on the wall.

After Rossetti's breakdown Jane sadly ended the affair, destroying most of his love letters. Spending long summers at Kelmscott, she also kept up an extensive correspondence. In her later life friends included Marie Spartali Stillman (who had also been in love with Rossetti), suffragist Jane Cobden, the first woman elected to the London County Council, and maverick W.S. Blunt, supporter of Irish and Arab nationalism, who numbered Jane among his conquests. She was extremely fond of the de Morgans and of Philip Webb, to whom she sent cases of wine. She also regularly visited Algernon Swinburne. Shyness and deep reserve made her appear silent, even sulky. 'Only her intimate friends knew the kindliness, the good sense and the girlish sense of fun which remained hers until the end of her life,' wrote her obituarist.

Edward Burne-Jones (1833–98)

The leading figure of Pre-Raphaelitism's second wave, with imaginative and romantic scenes painted in glowing colour harmonies, to the end of his life Burne-Jones remembered his worship of Dante Gabriel Rossetti. 'I was with him every day from morning till it was morning again, and at three-and-twenty one needs no sleep. His talk and his looks and his kindness ... I loved him and I thought him the biggest; and I think so still!'

Born in Birmingham, the son of a small businessman, Burne-Jones, known as Ned to his friends, met William Morris at Oxford, Rossetti through the Working Men's College – 'he is doing designs which quite put one to shame ... he will take the lead in no time' – and George Frederic Watts and Alfred, Lord Tennyson, at Little Holland House. From 1858 to 1859 he and Morris lived in Red Lion Square, in a studio formerly shared by Rossetti and Walter Deverell. He joined enthusiastically in the decoration of the debating chamber at Oxford University, was a founder member of the Hogarth Club and a partner in Morris & Co., being responsible for most of the firm's stained-glass designs. In John Ruskin's view, he was 'the most wonderful of all the Pre-Raphaelites in redundance of delicate and pathetic fallacy' and beyond all 'in grace and sweetness'. Later, critic and artist were less in sympathy; 'he quarrels with my pictures and I with his writings,' observed Burne-Jones.

No portraits convey the intensity of his pictorial imagination, concealed behind a mask of meekness. He also had a mischievous sense of fun, glimpsed in caricatures of his friends and the 'fat ladies' whom the slender artist abhorred. In painting, his dreamy, oval female faces became a hallmark of beauty. 'That moment you give what people call expression, you

Sir Edward Burne-Jones
Sir Philip Burne-Jones, 1898

'I mean by a picture a beautiful romantic dream of something that never was, never will be – in a light better than any light that ever shone – in a land no one can define or remember, only desire – and the forms divinely beautiful.' This late portrait by the Burne-Jones's son was given to the National Portrait Gallery in accordance with Georgiana's wishes.

destroy the typical character of heads and degrade them into portraits,' he wrote.

In 1860 he married Georgiana Macdonald; together with Elizabeth and Dante Gabriel Rossetti and Jane and William Morris, they formed a sub-set of young married couples. They were frequent visitors at Red House and, as the Burne-Jones and Morris children grew up, they often holidayed together. Within a decade, however, Burne-Jones's marriage was threatened by his love for Maria Zambaco whose features dominate his art in the 1870s, in such works as *Phyllis and Demophoön* (1870) and *The Beguiling of Merlin* (1874), but whom he eventually renounced. His artistic reputation, for works combining Pre-Raphaelitism with emerging Symbolism, was secured by the Grosvenor Gallery and in his last years he embarked on ever larger pictorial schemes, of Perseus, the Sleeping Beauty and Arthur in Avalon.

In 1894 he was made a baronet, to the dismay of many, including his wife and Morris. Though claiming to be a conservative, he hated imperialism – 'ours is only a material empire ... [and will] have to go someday' – and also so-called field sports. William de Morgan once heard him say, 'Never forget when you see a man with a gun, that he's a fool.'

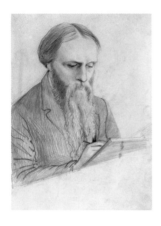

Sir Edward Coley Burne-Jones
George Howard, 9th Earl of Carlisle, c.1875

'Extremely pale he was, with the paleness that belongs to fair-haired people,' wrote Georgiana. 'His hair was perfectly straight, and of a colourless kind. From the eyes themselves power simply radiated and as he talked and listened, if anything moved him, not only his eyes but his whole face seemed lit up from within.' George Howard, later Earl of Carlisle, was a fellow artist and long-time friend of Burne-Jones.

Georgiana Burne-Jones (1840–1920)

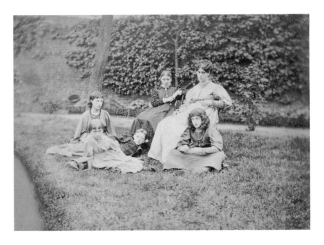

Georgiana Burne-Jones, Jane Morris and their children
Frederick Hollyer, *c*.1874

Georgie (as she was always known) is seated (centre) in the garden of her home in Fulham, with her son, Philip (1861–1926), and daughter, Margaret (1866–1953; front left), together with Jane Morris and her daughters, Jenny (1861–1935; far left) and May (1862–1938; right).

As resolute in soul as she was tiny in stature, Georgiana Macdonald entered the Pre-Raphaelite circle when she became engaged to Burne-Jones in 1856, aged fifteen. 'I wish it were possible to explain the impression made upon a young girl whose experience so far had been quite remote from art, by sudden and close intercourse with those to whom it was the breath of life,' she wrote. Known and loved as 'Georgie', she became a key figure in the later Pre-Raphaelite circle, her clear vision and candid judgement sustaining the social ideals of the movement, and made a lasting contribution to its history with her two-volume biography of her husband.

Born in Birmingham, daughter of a Methodist minister, she was an accomplished musician and also studied illustration, aiming to become a wood-engraver. Recalling early married life, she wrote, 'I thought it quite natural that in the middle of the morning I should ask our only maid to stand for me that I might try to draw her.' But though Ford Madox

93

Brown and Dante Gabriel Rossetti encouraged her endeavours, motherhood intervened and art was laid aside.

Discretion and loyalty were her standards, and while sometimes deploring their conduct, she was a staunch friend to both Algernon Swinburne and Simeon Solomon. Her true soulmate, however, was William Morris, who dedicated his handwritten 'Book of Verse' to her in 1870. With tacit mutual sympathy, they supported each other through troubled times – Ned's affair with Maria Zambaco and Janey's with Rossetti. When all was over, Georgie and Morris remained the closest friends.

She also was concerned with social questions, helped found the South London Art Gallery and late in life became a community representative at the family's second home in Sussex. 'She is so busy – she is rousing the village – she is marching about – she is going like a flame through the village,' reported her husband.

Always self-effacing, her lasting contributions to the Pre-Raphaelite movement include the steady gaze, with the penetrating judgement of eyes that Morris called 'the deep grey windows of her heart', shown in her husband's painting *King Cophetua and the Beggar-Maid* (1884), and her work on the biographies of Morris and Burne-Jones, which remain a major resource for historians.

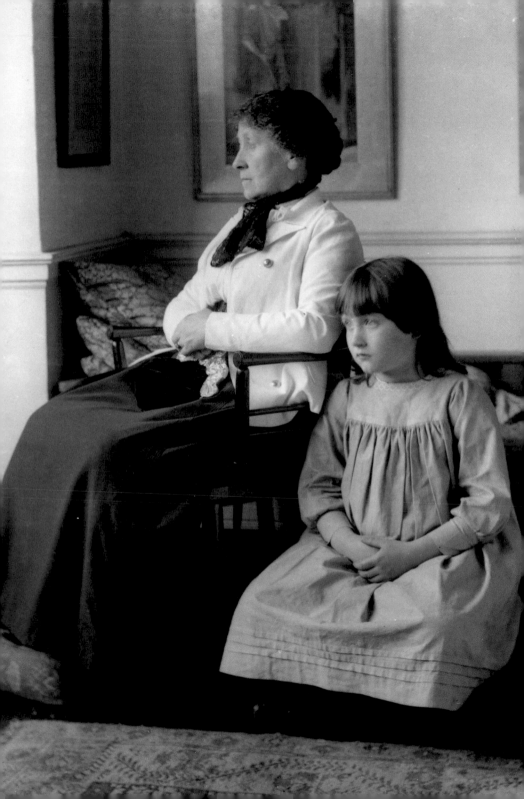

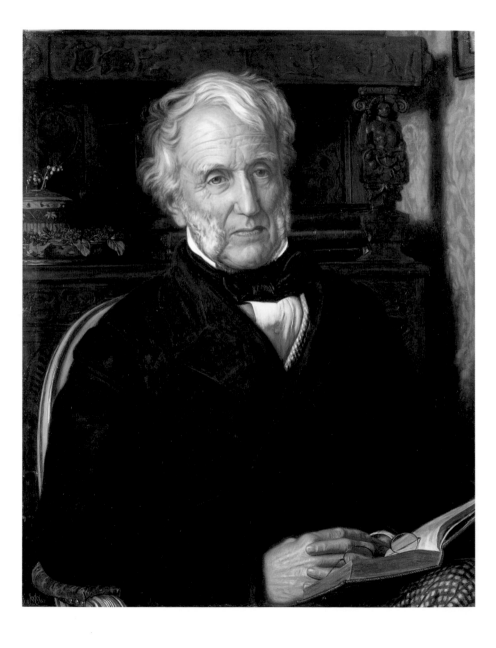

Stephen Lushington (1782–1873)

Lawyer, MP and reforming jurist Stephen Lushington was a leading figure in the campaigns to abolish slavery and to secure civil rights for all in the British Caribbean colonies. One of his sons, Vernon Lushington, QC (1832–1912), who shared his father's political views, taught alongside John Ruskin and Dante Gabriel Rossetti at the Working Men's College, where he introduced Edward Burne-Jones to Rossetti in 1856 and later the same year wrote on paintings by Rossetti and Ford Madox Brown for the *Oxford & Cambridge Magazine*.

In 1862 Vernon commissioned William Holman Hunt to paint this portrait of his father. The US Civil War was under way. Arriving at the Lushington home in Surrey, Hunt was greeted with a challenge: did he support North Union or South (Confederacy)? He was relieved when his reply was answered with the words, 'Oh good, we are all Northerners here.'

A strong likeness of a formidably principled and upright man, Holman Hunt's picture took time to complete. 'Of course as I only began it a month ago I am likely to stay here another eleven months,' he joked to Frederic Stephens; and though the artist returned to London it was indeed a year before he was satisfied. 'I think it the best painted portrait of modern times,' he wrote in October 1863.

A few months later Rossetti agreed to paint a portrait of Vernon's wife, and in 1883 Arthur Hughes produced a fine group portrait of Mrs Lushington and her daughters, Margaret, Katharine and Susan, as a musical quartet. Katharine (Kitty) was a friend of Julia Margaret Cameron's great-niece Virginia Woolf and the model for Mrs Dalloway.

Stephen Lushington
William Holman Hunt, 1862

'My father wished me to give this portrait of his father the Right Honourable Stephen Lushington by Holman Hunt to the National Portrait Gallery,' wrote Susan Lushington in 1912. 'I know that Holman Hunt considered it one of the best portraits he ever did.'

Philip Speakman Webb (1831–1915)

Philip Speakman Webb
Charles Fairfax Murray, 1873

'You brought me last evening
the most graceful, as well as the
most delightful gift you could
have made me – namely a
portrait of my life's friend,' wrote
sitter to artist on 18 March 1873.
He enclosed £10, 'to show
my gladness, but I cannot in
any way represent the value
of the gift'.

The most self-effacing of the partners in Morris
& Co., Philip Speakman Webb was perhaps the
most important after William Morris himself in the
practical understanding of design and production,
and a very loyal friend to all.

Born in Oxford, Webb trained as an architect,
meeting Morris and Edward Burne-Jones in 1856.
His first solo project was Red House – the 'palace
of art' – for the Morris family in Kent (now National
Trust), and for the firm he designed stained glass,
furniture, table glass and embroidery.

Philip Speakman Webb
Emery Walker

A man of simple tastes, according to his biographer, Webb enjoyed concerts and opera, but otherwise disliked grand social occasions, or being in the limelight.

Although he was renowned for working alone, his architectural output was nevertheless substantial; surviving commissions include the Green Dining Room at the V&A, Standen (now National Trust) and Clouds (Wiltshire). He designed homes for Val Prinsep, George Price Boyce and John Roddam Spencer Stanhope, and was an active member of the Society for the Protection of Ancient Buildings, with Morris, William Holman Hunt, Emery Walker and others. He also joined Morris in the socialist movement. He lived in Gray's Inn and never married, though he was close to Kate Faulkner, another Morris & Co. designer. Austere in his tastes, he disliked display, noting in 1875 that '[in] England it is thought degrading to live an economical and simple life'.

A good friend of Jane Morris, he was one of the best-loved figures in the Pre-Raphaelite circle, more than content to shelter in her husband's shadow. 'To both of us, the pulling down of the noisome chimney stack over the water [from Kelmscott] attached to the bankrupt sugar beet speculation there, gave great satisfaction,' he wrote, 'and we drank to a reformation of manners in future – alas, the drinking was not sufficient in quantity!' After he retired, Jane continued to send him welcome cases of whisky and wine. He left his possessions to Emery Walker, in whose Hammersmith house they remain.

Owing to his extremely retiring nature, there are few portraits of Webb; Charles Fairfax Murray's drawing (opposite) is a rare image, and the only photographs are snapshots, taken when he was not looking (left).

Algernon Charles Swinburne (1837–1909)

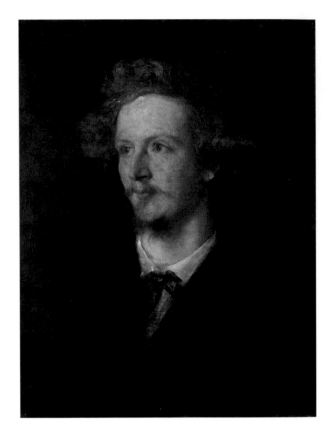

Algernon Charles Swinburne
George Frederic Watts, 1867

'I am in the honourable agonies of portrait-sitting – to Watts,' wrote Swinburne in May 1867. 'Of course it is a great honour to be asked to sit to him ... But it takes time and trouble, and he won't let me crop my hair, whose curls the British public (unlike Titian's) reviles in the streets ... But the portrait is a superb one already, in spite of the model, and up to the Venetian standard, by the admission of the other artists.'

Now regarded as one of the foremost Victorian poets, Swinburne first met the Pre-Raphaelites while they were decorating the debating chamber at Oxford University and eagerly joined their social circle, which regarded his poetic and alcoholic extravagances initially with amusement and later with dismay.

Born into the minor aristocracy with a country seat in Northumberland, Swinburne left Oxford to devote himself to poetry and excess, in admiration

of his hero Baudelaire. An affectionate friend of Elizabeth Siddal, he supported the opening of her coffin on the grounds that she cared most deeply about art and poetry.

Small in stature, with flaming red hair, he was nicknamed 'dear little Carrots' by Edward Burne-Jones, to whom Swinburne dedicated *Poems & Ballads* (1865), the book that made his name. These colourful poems outraged and enthralled with their alluring women who inspired the painters' femmes fatales:

> O beautiful lips, O bosom,
> More white than the moon's, and warm,
> A sterile, a ruinous blossom
> Is blown your way in a storm.
> You thrill as his pulses dwindle,
> You brighten and warm as he bleeds,
> With insatiable eyes that kindle
> And insatiable mouth that feeds.

Algernon Charles Swinburne with Adah Menken
Harry Furniss

During the winter of 1867–8 Swinburne had a passionate and public relationship with American-born entertainer Adah Isaacs Menken (1835–68), who scandalised British opinion with her theatrical performances as Mazeppa, a character from Byron, riding bareback and apparently unclothed. Photographs of Swinburne with Menken were displayed in various London shop windows.

With revolutionary views, he was also easily provoked, especially by critical reviews. 'No man living has a more vigorous command of the powers of invective,' wrote William Rossetti, 'to which his ingenuity of mind and ... mastery of literary resource, lend a lash of the most cutting and immedicable keenness.'

In 1864 Swinburne shared Tudor House with the Rossetti brothers, until his increasingly unruly behaviour – he and Simeon Solomon are said to have chased each other and slid down the banisters naked – threatened his friendships. In 1879 he was rescued by Theodore Watts-Dunton and taken to live soberly in Putney. Here he was visited by Jane Morris in 1896. 'He read us some of a new poem he is writing,' she reported. 'He is always rather difficult to follow, as he puts so much action into his reading and things roll off the table making noises. All the same, we enjoy our visits, he is so friendly.'

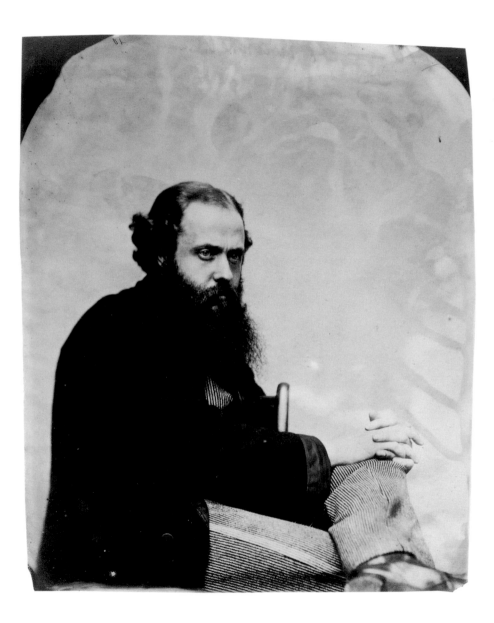

John Roddam Spencer Stanhope (1829–1908)

A rather shadowy member of the circle who has yet to receive much critical attention, Spencer Stanhope was drawn to the Pre-Raphaelites in the mid 1850s and followed their evolving style through from heightened realism to softer focus and colour harmonies. Founder member of the Hogarth Club and exhibitor at the Grosvenor Gallery, he was also mentor to his niece Evelyn de Morgan.

Born in Yorkshire to an upper-class family, he studied with George Frederic Watts and was often at Little Holland House. 'We had a whole pan full of the chief Pre-Raphaelites yesterday,' he wrote. 'There was Hunt, Rossetti and [Charles Alston] Collins. I submitted my picture to their inspection ... Rossetti is decorating the Union Club [and] has asked me to go and do something there.' In Oxford, he worked next to Edward Burne-Jones, who became a lifelong friend, and recalled how Spencer Stanhope's painting was admired: 'Rossetti was in a perfect state of enthusiasm about it: that's how he got to know him.' Spencer Stanhope's work at this period featured 'before and after' images of a fallen woman, painted in the studio below Rossetti's at Blackfriars. 'Called on Stanhope,' recorded George Price Boyce in December 1858. 'Fanny was sitting to him. She afterward went up to Rossetti and I followed.'

In 1860 Spencer Stanhope commissioned Philip Webb to build a house in Surrey, and a few years later he and his wife cared for William Holman Hunt's motherless son. During the 1870s Stanhope created a mural scheme for the chapel at Marlborough College. In 1873 he acquired a villa outside Florence, living there permanently after 1880. Pictorially, his subjects grew imaginative and mythological. According to Burne-Jones, he was 'the greatest colourist of his generation'.

John Roddam Spencer Stanhope
Lewis Carroll, spring 1857

'Roddam, an apostate from the traditions of his class, with the elasticity of an adaptable temperament, was equally at home in Bohemia or in fashionable society,' wrote his niece Wilhelmina, Evelyn de Morgan's sister.

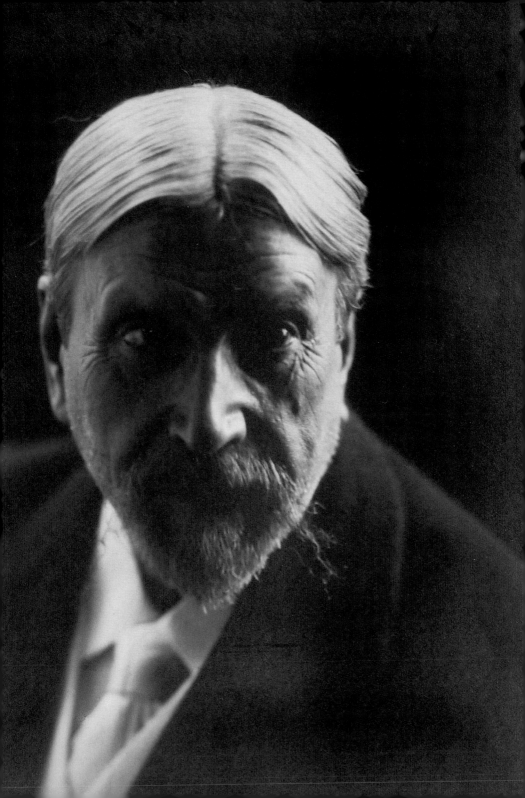

Anthony Frederick Sandys (1829–1904)

A highly talented but oddly feckless artist, Frederick Sandys first entered the Pre-Raphaelite circle through 'an impudent cartoon' satirically showing the three leading PRBs riding on an ass named John Ruskin. It made a great stir. Dante Gabriel Rossetti told William Morris he had heard it was by 'a man named Sandys'; some months later the two men met and became friends. At the same time, Sandys was working alongside Simeon Solomon and Albert Moore, and by 1862 he was 'a confirmed member of the confraternity'. 'You know I am only half settled at Chelsea yet,' Rossetti wrote to Sandys from Cheyne Walk. 'I really long to show it you & see how much you will be pleased with it.'

Born in Norwich, Sandys showed precocious talent, and first exhibited in London in 1851. Soon after joining the circle, he began to deploy his fine draughtsmanship and meticulous painting on Pre-Raphaelite subjects – medieval romances and femmes fatales, many of which are exceptional examples of the genre. An early marriage was short-lived, but never dissolved. In the 1860s he met the actress who became mother to his ten surviving children, as well as the gypsy woman known only as Keomi, a striking model for figures of Medea and Morgan le Fay.

Sandys's other talent was for arresting, original woodblock illustration, often on themes suggested by Algernon Swinburne, such as Cleopatra and Danae. He was known, too, for stylish portraiture, especially of the elderly, though never of his fellow artists. A good raconteur, he was a frequent guest of Ford Madox Brown, Rossetti and the Prinseps. But he was also a borrower – of money and of other people's ideas for pictures – and eventually friends lost patience. After 1870 he largely dropped out of the Pre-Raphaelite circle.

Anthony Frederick Sandys
Unknown photographer

This image of a suave and dapper clubman belies Sandys's other self – the spendthrift artist, freeloading on friends in exchange for exquisite drawings.

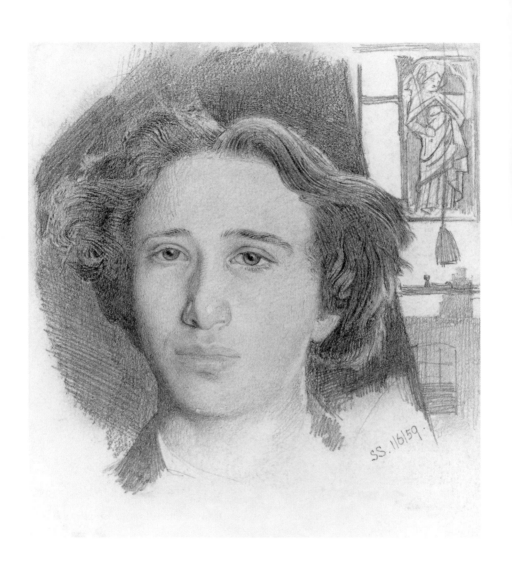

Simeon Solomon (1840–1905)

A younger member of the Pre-Raphaelite circle blessed with a pictorial imagination to rival theirs, Solomon first got to know Dante Gabriel Rossetti, Edward Burne-Jones and Algernon Swinburne in 1858, when William Michael Rossetti called him 'an artist of endless invention and fantasy, from whose original and teeming brain all hope great things indeed'.

Born in London into a Jewish business family, Solomon shared artistic gifts with his brother Abraham and sister Rebecca. At the age of fourteen he entered the Royal Academy Schools, where William de Morgan was a fellow student. Soon, Solomon was producing distinctively Pre-Raphaelite drawings; one illustrates 'Hand and Soul', Gabriel Rossetti's story in *The Germ*.

'I recollect that an album, stuffed full of a number of his designs, was handed about at a big gathering of men,' recalled William Rossetti. In 1859 Solomon worked alongside Frederick Sandys, and became friendly with the Burne-Joneses. He contributed designs to Morris & Co., but was especially close to Swinburne, who used some of his drawings as inspiration for ambiguously erotic poems.

His most Pre-Raphaelite works, depicting imaginative and biblical scenes, date from the early 1860s. Later works showed classical and Aesthetic influence. Visits to Italy resulted in a prose poem *A Vision of Love* (1871), but after he was convicted of homosexual offences in 1873 his career collapsed amid social ostracism and alcoholic addiction. 'Since then,' wrote William Michael Rossetti, 'I neither know nor wish to know anything about him.'

Simeon Solomon
Self-portrait, 1859

Solomon 'was the greatest artist of us all,' Burne-Jones is reported to have said. His imaginative compositions around the time of this self-portrait were those of 'the rising genius'.

Valentine Cameron Prinsep (1838–1904)

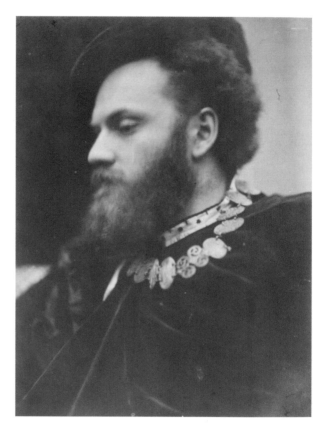

Valentine Cameron Prinsep
David Wilkie Wynfield, 1860s

As someone who enjoyed house parties and amateur dramatics, Prinsep was a natural recruit to Wynfield's photographs of artists in historical costume. For his aunt Julia Margaret Cameron he donned Tudor costume as Henry VIII.

Growing up in the company of, and as pupil to, George Frederic Watts at Little Holland House, Val Prinsep swung into the Pre-Raphaelite circle for the decoration of the debating chamber at Oxford University in 1857. 'I have conscientiously abstained from inoculating him with any of my own views,' wrote Watts, 'and have plunged him into the Pre-Raphaelite Styx ... now his gods are Rossetti, Hunt and Millais.'

Born in Calcutta, Val was the son of Sara and Thoby Prinsep and nephew of Julia Margaret Cameron. For a few years he joined enthusiastically in Pre-Raphaelite endeavours. Described as 'a thorough artist in his aspirations, a fine painter and a right good honest man', he took a studio near Edward Burne-Jones and spent much time in the company of Dante Gabriel Rossetti, whom he memorably took to witness a boxing match and who responded with a limerick:

> There is a big artist named Val
> The roughs' and the prize-fighters' pal
> > The mind of a groom
> > And the head of a broom
> Were nature's endowments to Val.

Large and boisterous, with a great shock of hair and bushy beard, Val was Rossetti's model for the figures of Sir Lancelot (at Oxford) and St George. After a spell in Paris, which led to his later immortalisation as a character in George Du Maurier's novel *Trilby*, he returned to London, joining the Hogarth Club, where he exhibited his most Pre-Raphaelite work, based on the traditional rhyme 'The Queen was in her parlour eating bread and honey'. In September 1860 he was introduced to Elizabeth Siddal, and a few months later invited to share 'oysters and obloquy' at Chatham Place with 'a few blokes and coves', including Ford Madox Brown, Algernon Swinburne and Frederick Sandys. In 1864 he asked Philip Webb to design his house in Holland Park.

Thereafter his artistic career took other directions, including his appointment as official artist for the events in Delhi when Victoria was proclaimed Empress of India. He became wealthy by marriage to the daughter of Frederick Leyland, the Liverpool ship-owner, who was a major Pre-Raphaelite patron.

Marie Spartali Stillman (1843–1927)

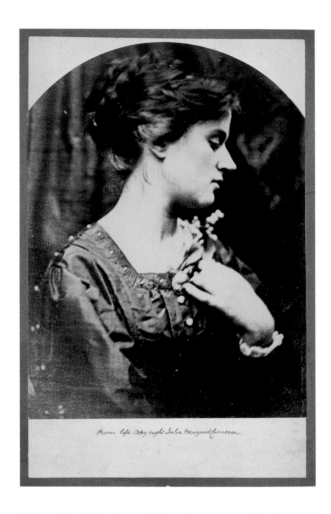

From life. Copy right Julia Margaret Cameron.

Marie Spartali (later Stillman)
Julia Margaret Cameron, 1868

'I longed to arrest all beauty that came before me,' wrote Cameron, who from 1867 to 1868 used Spartali as a model for an extensive sequence of photographs in costume and everyday dress.

'I hear that Miss Spartali is to be your pupil ... the marvellous beauty of whom I have heard much talk,' wrote Dante Gabriel Rossetti to Ford Madox Brown in 1864. 'So just box her up and don't let fellows see her as I mean to have first shy at her in the way of sitting.'

But it was Julia Margaret Cameron who first used Spartali as a model, in a sequence of pictures and portraits beginning in 1867. When Rossetti finally got his chance, he found the task harder than expected, for her beauty depended on the 'subtle charm of life' rather than stunning looks.

A member of the cultured Anglo-Greek community in London, Marie was one of a trio of young women nicknamed 'the three graces'; her sister Christine was the model for Whistler's *La Princesse du pays de la porcelaine* (1863–4). But Marie's life interest was art, which she practised professionally for sixty years, exhibiting at the Dudley, Grosvenor and New Galleries, remaining true to Pre-Raphaelite principles through the evolutions of personal style and subjects.

Exceptionally modest – she ruined her reputation by running down her own work, according to fellow painter Charles Fairfax Murray – Spartali was gentle, loyal and full of sympathy. 'She is a noble girl, in beauty, in sweetness and in artistic gifts,' wrote Rossetti to her husband; 'and the sky would seem very warm ... and the road in front bright and clear ... to him who starts on his life's journey foot to foot and hand in hand with her.' Having initially hoped to marry the widowed Rossetti, in 1871 Spartali accepted American journalist W.J. Stillman, a disciple of John Ruskin and friend of the Pre-Raphaelite Brotherhood, becoming stepmother to his daughters and raising a daughter and son of her own. From 1879, Stillman's work meant the family lived mainly in Italy, where Marie welcomed friends from England. She was especially close to Jane Morris and in later life was a frequent guest at Kelmscott Manor, where in her words 'things have been at a standstill for 300 years probably'. While there she painted several views of the house and garden. Her daughters became friends of Julia Margaret Cameron's great-nieces Vanessa (later Bell) and Virginia (later Woolf) Stephen.

William de Morgan (1839–1917) and Evelyn de Morgan (1855–1919)

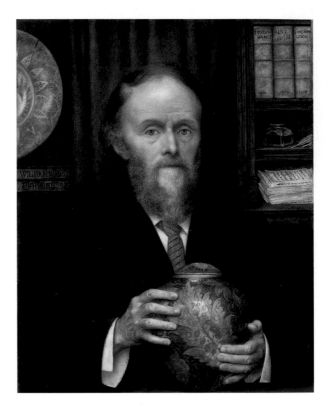

'Miss Pickering is going to marry Mr de Morgan who makes the lustreware,' Marie Spartali told her daughter in 1885. Thus painter and potter became Evelyn and William de Morgan in a Pre-Raphaelite partnership.

William de Morgan, the son of a mathematician, was an artist and then ceramicist who worked closely with William Morris – with whom he shared a taste for execrable puns. His tiles and lustreware vessels were often inspired by Islamic examples. 'The more

difficult the space to be filled and the more fantastic the beast pattern, the more enjoyment is evident,' wrote May Morris of his designs. The jar and half-seen plate in the portrait by Evelyn (opposite), which blends Pre-Raphaelite brushwork with Arts and Crafts imagery, are typical of his rich decorative colouring. In the bookcase behind are three of the novels he wrote when failing health ended his days as potter.

'William de Morgan is a dear old friend to all of us, his books are delightful, he sends me a copy always,' Jane Morris told her niece. 'We are

rejoicing in his success as an author which is very remarkable, he is now quite famous and made much of everywhere.'

Evelyn Pickering de Morgan, whose uncle was John Roddam Spencer Stanhope, fought family opposition to pursue a career in art. After studying at the Slade School, she made several trips to Italy, and allied herself with the Pre-Raphaelites, exhibiting with Edward Burne-Jones, Spartali and others at the Grosvenor Gallery. She seems to have roused unexpected rivalry in Burne-Jones, who went to her studio in 1897. Her pictures were 'wonderfully painted ... a kind of eclectic mix of Mr Watts and me and old Florentine work,' he reported. But 'at a distance the whole has no beauty of colour at all [and] the figures are so badly drawn'.

The canvases were large and the subjects chiefly allegorical and Symbolist, informed by the spiritualist beliefs Evelyn and William shared; together they experimented with a form of meditation that employed automatic writing.

Both de Morgans were very gentle souls, with a youthful sense of humour. A fine collection of their paintings and ceramics is on view at the De Morgan Foundation gallery in south London.

Lucy Madox Brown (1843–94)

Lucy Madox Brown
Unknown photographer, 1873

Taken in Rome not long before
she became engaged to William
Michael Rossetti, this portrait
comes from her sister's photo
album.

A talented artist in her own right, Lucy was daughter
to Ford Madox Brown and wife of William Michael
Rossetti, as well as friend to the Morrises, Marie
Stillman and Algernon Swinburne. She occupied
a key place in the widening Pre-Raphaelite circle
after 1860.

Born in Paris and still an infant when her mother
died, Lucy Brown was partly educated by the women
of the Rossetti family. Described by her younger sister
as 'a strange mixture with a violent temper and a
strong brain', she took an intellectual interest in

political affairs and the arts; according to Dante Gabriel Rossetti, her conversation was 'sensible, practical, and coloured by high thought and sympathy in the pictorial and poetic arts'. However, she also relished the parties at the Madox Brown home in Fitzroy Square, to which half the art world was invited. A contemporary recalled the sisters' high-waisted cashmere dresses in 'dull brick red, peacock blue, sage green and cinnamon brown', worn with jewellery 'of the barbaric kind ... the whole effect was Rossettian and Burne-Jonesian to the extreme'.

Around 1868, Lucy began to paint in her father's studio alongside sister Cathy and brother Oliver as well as Marie Spartali, so successfully that her exhibition debut took place the next year, with a picture of Cathy at the easel, praised for its harmony and sober colour. In 1870 *The Duet* contributed to the emerging Aesthetic style, though her preference was for more dramatic subjects, such as Romeo at Juliet's tomb. Her most daring subject showed Sir Thomas More's daughter rescuing his head from the traitor's spike on London Bridge.

Her painting of Ferdinand and Miranda from *The Tempest* included a portrait of her husband-to-be as Prospero. In 1873 Lucy went with the Bell Scotts, Alice Boyd and William Rossetti on a trip to Italy, during which she and William became engaged. Their wedding brought many Pre-Raphaelite gifts: Chinese and Japanese china from George Boyce, side dishes from Arthur Hughes, a magnificent inlaid chest from William Holman Hunt and a fine portrait drawing of Lucy from Dante Gabriel Rossetti.

Her hopes of continuing her career were impeded by the arrival of five children within eight years. Swinburne wrote verses on the birth of twins Mary and Michael, and Michael's subsequent death. Lucy's later years were largely spent as an invalid, but in 1886 she completed a biography of Mary Shelley.

Lucy Madox Brown
Dante Gabriel Rossetti, 1874

'No more welcome news could have reached me than that of your engagement,' wrote the artist to his prospective sister-in-law. This chalk portrait was a wedding present to the newly married couple.

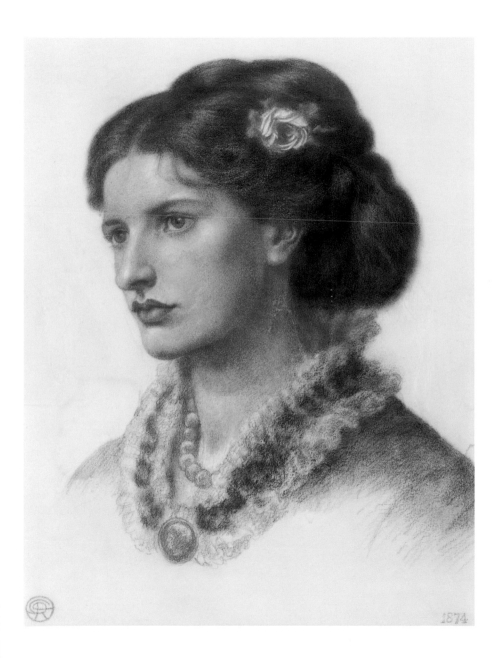

May Morris (1862–1938)

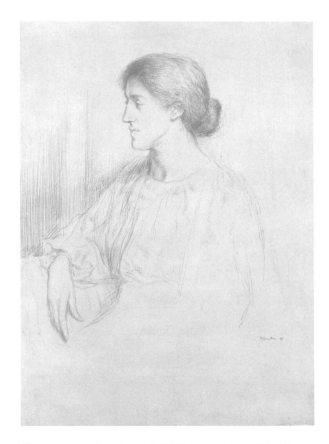

May Morris
Sir William Rothenstein, 1897

'You see William Morris could design but he could not embroider. [Jane] Morris could embroider but couldn't design. May Morris did both design as well as William Morris and embroider as well as anyone,' wrote May's companion Mary Lobb to the director of the Victoria & Albert Museum. 'That is what so few grasp and appreciate. They need to have their noses rubbed in it.'

The younger daughter of William and Jane Morris, who became a leading textile artist in the Arts and Crafts movement, May was born at Red House, Kent, but grew up in dingy Queen Square, Bloomsbury, where Morris & Co. had its base and the stained glass was produced. She and her sister Jenny enjoyed an unconventional artistic upbringing, especially from 1871, when Kelmscott Manor became their summer playground. Both were rather tomboyish. 'May is far

the prettier – quite a beauty indeed,' noted William Michael Rossetti.

Dante Gabriel Rossetti used the girls as occasional models, once asking if he might adopt May in place of the child he and Lizzie had lost. Christmases were spent with the Burne-Jones children, collaborating on a secret society and a house magazine whose contributors included the young Rudyard Kipling, Georgiana's nephew.

After developing epilepsy, Jenny Morris became an invalid, while May studied at the South Kensington School of Design. In 1885 she took on responsibility for the embroidery department of Morris & Co., where the employees included Mary de Morgan, the potter's sister, and Lily Yeats, sister of the poet. May joined her father in the Socialist League and was a keen admirer of Ibsen's 'new drama', acting with Eleanor Marx in a pioneering performance of *The Doll's House*. Though George Bernard Shaw claimed a 'mystic betrothal', May's love for him remained unfulfilled; instead she was briefly married to a socialist comrade.

The loss of her father, coupled with romantic disappointment, gave May an air of discontent. She lived for many years near Emery Walker in Hammersmith Terrace and, as a leading figure in the Arts and Crafts movement, she founded the Women's Guild of Art, the Art Workers' Guild being men-only. She also taught at the Central School, edited her father's *Collected Works* in twenty-four volumes, and energetically promoted the conservation and welfare of Kelmscott village, where she retired. 'I'm a remarkable woman,' she told Shaw in 1936, 'though none of you seemed to think so.'

Emery Walker (1851–1933)

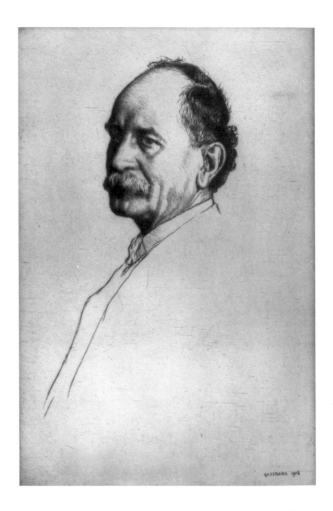

Sir Emery Walker
William Strang, 1906

No day was complete without
a chat to Walker, William
Morris declared.

Engraver, typographer and close colleague of William
Morris, Walker was born in London and began
work in a printing firm. In 1886 he founded the
engraving and photographic firm that later bore his
name. He lived in Hammersmith, where at first the

Morris family knew him only by his brown velveteen suit, until in 1884 he and Morris fell into conversation on the train back from a socialist meeting in the East End of London. He was active in the Society for the Protection of Ancient Buildings, and in the Arts and Crafts Exhibition Society, where in 1888 he lectured on early typography, with slides.

'He was very nervous and ought to have written down his words,' reported Morris, who was excited by the images, as his daughter May remembered. 'Talking to Emery Walker on the way home, he said, "Let's make a new fount of type." And that is the way the Kelmscott Press came into being.'

Morris began by designing typefaces on a large scale. 'When done, each letter was photographed down to the size the type was to be. Then he and Walker criticized them and brooded over them; then he worked on them again.' Partners in all but name, they collaborated on a daily basis. Walker worked especially closely on translating Burne-Jones's illustrations for the Kelmscott Chaucer from paper to photograph to woodblock.

His firm, with its printing works next door to Morris's home, also played a crucial role in reproducing both likenesses and art works of the Pre-Raphaelite circle, including several of the portraits of William Morris taken by Frederick Hollyer. In 1956 a large stock of copy and original glass negatives by Emery Walker Ltd were spotted by the wife of David Piper of the National Portrait Gallery as she pushed her baby in a pram alongside the river at Hammersmith. They were being thrown into a skip. She rang her husband and the collection went into storage at the Gallery until 1986, when its 30,000 negatives were catalogued for the Photographic Archive. Most are images of art works, but a few are portraits from life.

Interior of Emery Walker's house at 7 Hammersmith Terrace

Walker lived at 7 Hammersmith Terrace, London, close to May Morris and Frederic Stephens. The interior, virtually unchanged since his death, contains Philip Webb's furniture, textiles, photos of the Morris family and many Pre-Raphaelite and Arts and Crafts items.

Select bibliography

Allingham, William, *The Diaries*, ed. H. Allingham and D. Radford (Penguin Books, Harmondsworth, 1985; Folio Society, London, 1990)

Burne-Jones, Georgiana, *Memorials of Sir Edward Burne-Jones*, 2 vols (1904; reprinted Lund Humphries, London, 1993)

Chapman, Alison, and Stabler, Jane (eds), *Unfolding the South: Nineteenth-century British Women Writers and Artists in Italy* (Manchester University Press, Manchester, 2003)

Cooper, Suzanne Fagence, *Pre-Raphaelite Art in the Victoria & Albert Museum* (V&A Publications, London, 2003)

Elzea, Betty, *Frederick Sandys* (exh. cat., Antique Collectors' Club, Woodbridge, Suffolk, 2001)

Ford, Colin, *Julia Margaret Cameron: 19th Century Photographer of Genius* (National Portrait Gallery, London, 2003)

Fredeman, W.E. (ed.), *The PRB Journal* (Clarendon Press, Oxford, 1975)
— *The Correspondence of Dante Gabriel Rossetti* (D.S. Brewer, Woodbridge, Suffolk, 2002)

Funnell, Peter, and Warner, Malcolm, *Millais: Portraits* (National Portrait Gallery, London, 1999)

Gillett, Paula, *The Victorian Painter's World* (Alan Sutton, Stroud, Gloucestershire, 1990)

Gordon, Catherine, *Evelyn de Morgan* (De Morgan Foundation, London, 1996)

Harrison, Antony H., *The Letters of Christina Rossetti*, 3 vols (University of Virginia Press, Charlottesville, VA, 1997–2000)

Hilton, Tim, *John Ruskin: The Early Years* (Yale University Press, New Haven, CN, 1985)
— *John Ruskin: The Later Years* (Yale University Press, New Haven, CN, 2000)

Hunt, William Holman, *Pre-Raphaelitism and the Pre-Raphaelite Brotherhood*, 2 vols (Macmillan, London, 1905)

Kelvin, Norman (ed.), *The Collected Letters of William Morris*, 4 vols (Princeton University Press, Princeton, NJ, 1984–96)

Lago, Mary (ed.), *Burne-Jones Talking: His Conversations 1895–98* (John Murray, London, 1982)

Lang, Cecil Y., *The Letters of Swinburne*, 6 vols (Yale University Press, New Haven, CN, 1959–62)

MacCarthy, Fiona, *William Morris: A Life for Our Time* (Faber & Faber, London, 1994)

Marsh, Jan, *Christina Rossetti: A Literary Biography* (Jonathan Cape, London, 1994)
— *Dante Gabriel Rossetti: Painter and Poet* (Weidenfeld & Nicolson, London, 1999)

Marsh, Jan, and Nunn, Pamela Gerrish, *Pre-Raphaelite Women Artists* (Thames & Hudson, London, 1998)

Martin, Robert Bernard, *Tennyson: The Unquiet Heart* (Faber & Faber, London, 1983)

Newall, Christopher, and Egerton, Judy, *George Price Boyce* (exh. cat., Tate Gallery, London, 1987)

Newman, Teresa, and Watkinson, Ray, *Ford Madox Brown and the Pre-Raphaelite Circle* (Chatto & Windus, London, 1991)

Nunn, Pamela Gerrish, *Victorian Women Artists* (Women's Press, London, 1987)

Olsen, Victoria, *From Life: Julia Margaret Cameron and Victorian Photography* (Aurum, London, 2003)

Parris, Leslie (ed.), *Pre-Raphaelite Papers* (exh. cat., Tate Gallery, London, 1984)

Peattie, Roger, *Selected Letters of William Michael Rossetti* (Pennsylvania State University Press, PA, 1990)

The Pre-Raphaelites (exh. cat., Tate Gallery, London, 1984)

Roberts, Len, *Arthur Hughes: His Life and Works* (Antique Collectors' Club, Woodbridge, Suffolk,1997)

Rose, Andrea, *Pre-Raphaelite Portraits* (Oxford Illustrated Press, Oxford, 1981)

Rossetti, William M., *The Germ: Thoughts towards Nature in Poetry, Literature and Art* (1850; reprinted Ashmolean Museum, Oxford, 1979)

— *Some Reminiscences* (Brown & Langham, London, 1906)

Rothenstein, William, *Men and Memories*, Vol. I (Faber & Faber, London, 1931)

Scott, William Bell, *Autobiographical Notes*, 2 vols (Osgood & McIlvaine, London, 1892)

Smith, Elise Lawton, *Evelyn Pickering de Morgan and the Allegorical Body* (Associated University Presses, Cranbury, NJ, 2002)

Staley, Allen, *Pre-Raphaelite Landscape* (exh. cat., Tate Gallery, London, 2004)

Stanford, Derek (ed.), *Pre-Raphaelite Writing* (J.M. Dent, London, 1973)

Surtees, Virginia (ed.), *Diary of Ford Madox Brown* (Yale University Press, New Haven, CN, 1981)

Thirlwell, Angela, *William and Lucy: The Other Rossettis* (Yale University Press, New Haven, CN, 2003)

Tickner, Lisa, *Rossetti* (Tate Gallery, London, 2003)

Treuherz, Julian, et al., *Dante Gabriel Rossetti* (Waanders Publishers, Zwolle, The Netherlands, 2003)

Wildman, Stephen, and Christian, John, *Edward Burne-Jones: Victorian Artist-Dreamer* (exh. cat., Metropolitan Museum, New York, 1998)

Woolner, Amy, *Thomas Woolner R.A.: Sculptor and Poet* (E.P. Dutton, London, 1917)

List of illustrations

p.38 (bottom) **W.M. Rossetti**, Sir William Rothenstein, c.1909. Oil on canvas, 597 x 495mm (23½ x19½"). © National Portrait Gallery, London (NPG 2485)

p.39 (detail) **Algernon Charles Swinburne, Dante Gabriel Rossetti, Fanny Cornforth and William Michael Rossetti**, probably by William Downey, c.1863. Albumen carte-de-visite. © Fitzwilliam Museum, Cambridge

p.40 **Thomas Woolner**, Ralph Winwood Robinson, 20 August 1889. Platinum print, 202 x 154mm (8 x 6⅛"). © National Portrait Gallery, London (NPG x7402); p.42 **T. Woolner**, Dante Gabriel Rossetti, 1852. Pencil, 155 x 146mm (6⅛ x 5¼"). © National Portrait Gallery, London (NPG 3848)

p.45 **Christina Rossetti and her mother, Frances Rossetti**, Dante Gabriel Rossetti, 1877. Chalk, 425 x 483mm (16¾ x 19"). © National Portrait Gallery, London (NPG 990)

p.46 **Frederic George Stephens**, Sir John Everett Millais, 1853. Pencil, 216 x 152mm (8½ x 6"). © National Portrait Gallery, London (NPG 2363)

p.48 **Ford Madox Brown**, Dante Gabriel Rossetti, 1852. Pencil, 171 x 114mm (6¾ x 4½"). © National Portrait Gallery, London (NPG 1021); p.49 **F.M. Brown**, W. & D. Downey, early 1860s. Albumen carte-de-visite, 92 x 60mm (3⅝ x 2⅜"). © National Portrait Gallery, London (NPG Ax7568)

p.50 **William Allingham**, Helen Allingham, 1876. Watercolour, 292 x 235mm (11½ x 9¼"). © National Portrait Gallery, London (NPG 1647)

p.52 **Walter Howell Deverell**, William Holman Hunt, 1853. Black and red chalk on toned paper, 355 x 260mm (14 x 10¼"). © Birmingham Museums & Art Gallery

p.54 **William Wilkie Collins**, John Everett Millais, 1850. Oil on panel, 267 x 178mm (10½ x 7"). © National Portrait Gallery, London (NPG 967)

p.57 **Arthur Hughes**, John Brett, 1858. Pencil, 207 x 224mm (8⅛ x 8¾"). © National Portrait Gallery, London (NPG 6483); p.58 **A. Hughes**, self-portrait, 1851. Oil on millboard, 152 x 127mm (6 x 5"). © National Portrait Gallery, London (NPG 2759)

p.60 **John Ruskin**, Sir Hubert von Herkomer, 1879. Watercolour, 737 x 483mm (29 x 19"). © National Portrait Gallery, London (NPG 1336); p.62 **J. Ruskin**, Sarah Acland, 1893. Matt bromide print, 167 x 120mm (6⅝ x 4¾"). © National Portrait Gallery, London (NPG x5588)

p.64 **Euphemia ('Effie') Chalmers, Lady Millais**, Thomas Richmond, 1851. Oil on board, 810 x 530mm (31⅞ x 20⅞"). © National Portrait Gallery, London (NPG 5160); p.65 **E. Chalmers**, Herbert Watkins, late 1850s. Albumen print, 188 x 142mm (7⅜ x 5½"). © National Portrait Gallery, London (NPG P301(37))

p.66 **George Price Boyce**, unknown photographer, early 1860s. Modern print from an original negative. © National Portrait Gallery, London (NPG x25221)

p.68 **Joanna Boyce Wells**, Dante Gabriel Rossetti, 15 July 1861. Photograph of a pen-and-ink drawing now destroyed. © National Portrait Gallery, London (NPG RN37237); p.69 **J. Boyce Wells**, Dante Gabriel Rossetti. Photograph of a pen-and-ink drawing now destroyed. © National Portrait Gallery, London (NPG RN37236)

p.70 **Elizabeth Siddal**, Dante Gabriel Rossetti, 1860. Pencil, 254 x 248mm (10 x 9¾"). © Fitzwilliam Museum, Cambridge; p.71 **E. Siddal with Dante Gabriel Rossetti**, after an original pen-and-ink drawing by Dante Gabriel Rossetti of 1853. Reproduction, 140 x 195mm (5 x 7⅝"). © National Portrait Gallery, London (NPG D9348)

p.72 **William Bell Scott**, Frederick Bacon Barwell, 1877. Oil on canvas, 511 x 406mm (20⅛ x 16"). © National Portrait Gallery, London (NPG 6105)

p.74 **John Brett**, unknown photographer, 1880s. © National Portrait Gallery, London (NPG x5175)

p.76 **Alfred Tennyson, 1st Baron Tennyson**, George Frederic Watts, c.1863–4. Oil on canvas, 613 x 514mm (24⅛ x 20¼"). © National Portrait Gallery, London (NPG 1015); p.78 **A. Tennyson**, Julia Margaret Cameron, 1869. Albumen print, 289 x 248mm (11⅜ x 9¾"). © National Portrait Gallery, London (NPG P9)

p.79 **Julia Margaret Cameron**, George Frederic Watts, 1850–52. Oil on canvas, 610 x 508mm (24 x 20"). © National Portrait Gallery, London (NPG 5046); p.81 **J.M. Cameron**, Henry Herschel Hay Cameron, 1870. Albumen print, 244 x 203mm (9⅗ x 8"). © National Portrait Gallery, London (NPG P696)

p.82 **George Frederic Watts**, Julia Margaret Cameron, c.1863–8. Albumen print, 254 x 197mm (10 x 7¾"). © National Portrait Gallery, London (NPG P125)

p.84 **William Morris**, George Frederic Watts, 1870. Oil on canvas, 648 x 521mm (25½ x 20½"). © National Portrait Gallery, London (NPG 1078); p.86 **W. Morris**, Frederick Hollyer, 1874. Platinum print, 135 x 96mm (5⅜ x 3¾"). © National Portrait Gallery, London (NPG x3762)

p.88 **Jane Morris**, Dante Gabriel Rossetti, c.1865. Charcoal, 343 x 292mm (13½ x 11½"). © Philadelphia Museum of Art: Gift of an anonymous donor in memory of Alfred Bendiner, 1972

p.90 **Sir Edward Burne-Jones**, Sir Philip Burne-Jones, 1898. Oil on canvas, 749 x 533mm (29½ x 21"). © National Portrait Gallery, London (NPG 1864); p.92 **E.C. Burne-Jones**, George Howard, 9th Earl of Carlisle, c.1875. Pencil, 216 x 140mm (8½ x 5½"). © National Portrait Gallery, London (NPG 5276)

p.93 **Georgiana Burne-Jones, Jane Morris and their children**, Frederick Hollyer, c.1874. Modern print from an original negative. © Hammersmith and Fulham Archives and Local History Centre

p.95 **Georgiana Burne-Jones and her granddaughter Angela Thirkell**, Emery Walker. Modern print from an original negative. © National Portrait Gallery, London (NPG x19622)

p.96 **Stephen Lushington**, William Holman Hunt, 1862. Oil on canvas, 819 x 648mm (32¼ x 25½"). © National Portrait Gallery, London (NPG 1646)

p.98 **Philip Speakman Webb**, Charles Fairfax Murray, 1873. Wash, 314 x 254mm (12⅜ x 10"). © National Portrait Gallery, London (NPG 4310); p.99 **P.S. Webb**, Emery Walker. Modern print from an original negative. © National Portrait Gallery, London (NPG x29688)

p.100 **Algernon Charles Swinburne**, George Frederic Watts, 1867. Oil on canvas, 648 x 521mm (25½ x 20½"). © National Portrait Gallery, London (NPG 1542); p.101 **A.C. Swinburne with Adah Menken**, Harry Furniss. Pen and ink, 254 x 197mm (10 x 7¾"). © National Portrait Gallery, London (NPG 6251(60))

p.102 **John Roddam Spencer Stanhope**, Lewis Carroll, spring 1857. Albumen print, 146 x 121mm (5¾ x 4¾"). © National Portrait Gallery, London (NPG P7(15))

p.104 **Anthony Frederick Sandys**, unknown photographer. 146 x 193mm (5¾ x 7¾") © Maas Gallery, London

p.106 **Simeon Solomon**, self-portrait, 1859. Pencil, 165 x 146mm (6½ x 5¾"). © Tate, London 2004

p.108 **Valentine Cameron Prinsep**, David Wilkie Wynfield, 1860s. Albumen print, 215 x 161mm (8½ x 6⅜"). © National Portrait Gallery, London (NPG P95)

p.110 **Marie Spartali (later Stillman)**, Julia Margaret Cameron, 1868. Albumen cabinet card, 133 x 99mm (5¼ x 3⅞"). © National Portrait Gallery, London (x18051)

p.112 **William Frend de Morgan**, Evelyn de Morgan, 1909. Oil on canvas, 689 x 546mm (27⅛ x 21½"). © National Portrait Gallery, London (NPG 6358)

p.113 **Evelyn de Morgan**, unknown photographer. © The De Morgan Foundation

p.115 **Lucy Madox Brown**, unknown photographer, 1873. © The Parliamentary Archives, House of Lords Records Office; p.117 **L. Madox Brown**, Dante Gabriel Rossetti, 1874. Chalk. © Private Collection

p.118 **May Morris**, Sir William Rothenstein, 1897. Silverpoint, 318 x 241mm (12½ x 9½"). © National Portrait Gallery, London (NPG 3049)

p.120 **Sir Emery Walker**, William Strang, 1906. Etching, 368 x 238mm (14½ x 9⅜"). © National Portrait Gallery, London (NPG 5977)

p.121 **Interior of Emery Walker's house at 7 Hammersmith Terrace**. © Country Life Picture Library

Index

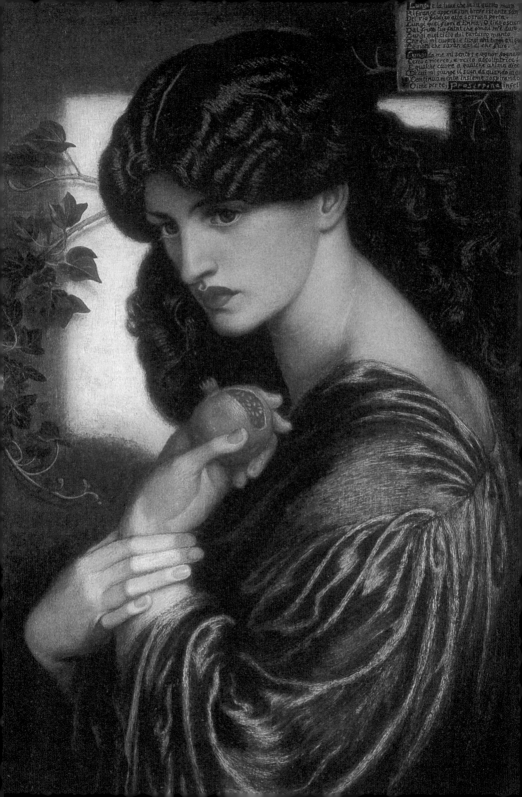